IMAGES
of America

OCEAN CITY

VOLUME I

IMAGES
of America

OCEAN CITY

VOLUME I

Nan DeVincent-Hayes, Ph.D.
and John E. Jacob

ARCADIA
PUBLISHING

Published by Arcadia Publishing
Charleston, South Carolina

Printed in the United States of America

Library of Congress Catalog Card Number: 99-62865

For all general information contact Arcadia Publishing at:
Telephone 843-853-2070
Fax 843-853-0044
E-mail sales@arcadiapublishing.com
For customer service and orders:
Toll-Free 1-888-313-2665

Visit us on the Internet at www.arcadiapublishing.com

*In grateful appreciation to John's wife, and Nan's family, for their understanding
and helpfulness during the researching and writing of this book.*

CONTENTS

PREFACE

Living between the Atlantic Ocean and the Chesapeake Bay gives us incentive to write about the summer's second largest city on the shore. Being authors and seeing the seaside resort as a unique place unparalleled elsewhere, we decided to write about it. When we began this project, we never anticipated the amount of time and energy it would require, because Ocean City, unlike other small municipalities, has grown rapidly, changed in topography and geography, faced uncommon challenges, and forged a leading edge atypical of small towns.

Because of the resort's growth, we collected more photos and postcards, information, and exhibits than any single book could handle. Hence, we've divided the project into two bodies, using dates as cut-off points. This volume offers a historical perspective of Ocean City from its inception to the year 1946 when growth was slow but steady; Volume II looks at the years from 1947 to the present when growth pulsed and surged to an explosive point. The cut-off periods are arbitrary since many dates are indeterminable.

Unless otherwise noted, postcards appearing here have come from the collection of John Jacob. In both volume I and volume II, postcards from personal collections serve as the major source of images. Postcard collection is an art in itself, and thus this book offers not only a pictorial history but also the added gift of collectors' treasures. Some of the images have been purchased from retailers, while others come from various archives, as well as from individuals' private albums (some of which are well over 60 years old). Each offers a rich history and a momentary reflection on the past when life seemed simpler, friends and family were closer to us, and bureaucracy nothing more than an 'X' signed at the bottom of a single sheet of paper.

So sit back and examine the following pictures, place yourself inside them, relish every special old-time moment, and be sure to pick up Volume II to complete your understanding of Ocean City's history.

Enjoy!

Nan DeVincent-Hayes, Ph.D., and John E. Jacob
Salisbury, Maryland, 1999

ACKNOWLEDGMENTS

We owe a debt of thanks to the many who helped us put this book together. We are grateful for the research materials they've extended to us, and the time they've given us in countless personal and phone interviews, as well as through e-mails and letters. If any name is accidentally omitted here, know that we appreciate all you have done. So with deep appreciation we thank the following: Suzanne Hurley, historian and director of the Ocean City Lifesaving Museum, for all her time and generosity in answering endless questions; her book (with George M. Hurley), *Ocean City: A Pictorial History*, has been an immense help to us; Mary Corddry, historian and author, for her kindness in answering questions and for the use of her book: *City on the Sand*; Donna Abbott, public relations director of Ocean City, for her help; Ocean City Chamber of Commerce for the written materials; Landy Taylor, operator of Santa Maria Motel, for a history of motels; Carleton and Dorothy Bloodgood of the Metropolitan Postcard Club of New York City and New Jersey for meeting with us and sharing their postcards; Vera Mariani for her contacts and input; David Dypsky for allowing us to borrow cards from his collection; Frances Massey Black for her sage comments; Imogene Pierce for sharing her memories; Roscoe Nelson for his insights on West Ocean City; Louis McBriety for his special remembrances; William Quigley Bennett for his personal photo album; William Ahtes for his advice on Ocean City's flying history; Dr. F.J. Townsend for a personal interview and his photo; our agent, Ivy Fischer Stone of the Fifi Oscard Agency, who is a postcard collector herself, for her wisdom and the materials she sent us; the late Fred Brueckmann for his great photographic skills and for his permission in allowing us to reprint his postcards; and to his wife, Frances, for searching their archives and gathering and making available to us their personal pictures, newspapers, books, and other materials; Ocean City engineers, officers, business owners, and the many others who gave of their time, knowledge, and remembrances; John Jacob for his years of collecting postcards and his generosity in presenting them in this book; and to the following postcard publishers and photographers for permitting us to include their fine work in our book. Forgive us if we accidentally overlooked anyone: Tingle Postcards; Harry P. Cann & Bros.; Fred Brueckmann; "M"; C.H. Ruth; Washington Pharmacy; Delmarva Postcards; W. Quigley Bennett; Roland Bynaker, Trade Winds; Rinn Publishing; Paul Smith, Eastern Shore Photography; The Chessler Co.; Frontier Town; R.D. Driscoll; Edward Stores; National Press; Bill Bard & Associates; Beals; William Campion; C.T. American Art; Chuck West; Curt Teich & Co.; Christoff; Albertype Co.; HPS/Pulling; Dexter Press; Spetzler, Connor & Coffin; Tichnor Bros.; C.P. Coffin; Arthur

Livingston; Coffin's Bazaar; E.B. Thomas; Louis Kaufmann & Sons; Aladdin; Franz Huld; Illustrated Postcard Co.; Art Baltrotsky, photographer; and Billy Waterman.

Additionally, we are eternally grateful to the following writers/researchers for their perseverance in gathering facts and for their endless help in putting this book together: Kyle Spolski, Mike Heinlein; Sean Niner, Erik Finkelstein; Kelly Choy, Tara Dillworth; Matt Cwalina, Chris Stellaccio; Kenna Bringham, Carol Hussey; Robert Finkbeiner, Jeff Disharoon; Kelly Cassell, Holly Anne McCardell; Megan Coombs, and a special thanks to Bo Bennett who did extensive research for us.

We especially want to thank our editor, Christine Riley, who has been more than understanding and helpful throughout this project. Always she was there for us, willing to give up her time to gently guide us and ardently encourage us. Thanks, Christine.

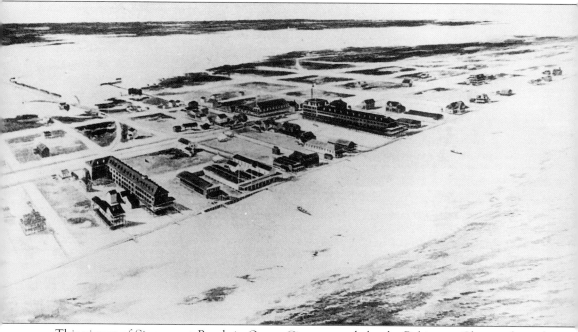

This picture of Sinepuxent Beach in Ocean City was made by the Baltimore, Chesapeake and Atlantic Railroad, the successor to the Wicomico and Pocomoke. The train is shown crossing the bridge to the mainland. The principal buildings shown are, from left to right, the Cambridge Hotel, Congress Hall, the Seabright Hotel, Hobbs Bath House and the Eastern Shore Hotel, the Hotel de Cropper, the Hotel Belvidere, the Casino, a cottage, and the Atlantic Hotel and dancing cotillion. The Seaside Hotel is on Baltimore Avenue in the center of the picture. The Life Saving Station, with the visible tower, is the last building in the picture. (Courtesy of the late Fred Brueckmann.)

INTRODUCTION

Two phrases that best characterize Ocean City are "family oriented" and "family owned." This post-Civil War resort presently has no casino gambling or slot machines. Many of its businesses are mom and pop operations that have been passed down from ancestors.

Ocean City is a "barrier island," meaning that it serves as a wall to the mainland—the Delmarva Peninsula—and thus protects it. This island once ran from Delaware's Indian River Inlet to Tom's Cove, Virginia (abut 60 miles long), but after the wicked 1933 storm, which eroded the land to form a waterway, Ocean City's land basin ended at what is now called the "Inlet." This hot-spot vacation center, which has accommodated many celebrities and noted politicians, houses over 7,000 permanent residents, many of whom are offspring of original settlers. The resort is Maryland's golden-haired child because it boasts over eight million visitors annually. During peak seasons, it's the state's second largest city with an average 300,000 tourists each weekend, filling nearly the width of its five blocks and the length of its 10 miles.

Accessing the beach in high months is frustrating since there are only three roads leading in and out of town. Condos and high-rise structures saturate Ocean City's northern region, while the southern end advances the boardwalk, shops, and the inlet. Hundreds and hundreds of rental properties, hotels, motels, camps, mobile home parks, restaurants, businesses, shops, amusements, and real estate companies steep the resort, though it doesn't have a hospital, school, or cemetery. The closest large city is Salisbury, Maryland, which serves as the Eastern Shore's hub.

A planned resort, Ocean City's original ownership came under Lord Baltimore. Before his proprietorship, the land was inhabited by the Algonquian tribe, consisting of the Pocomoke, Nanticoke, Assateague, and Chincoteague Indians, although some discrepancies exist as to which Native Americans really populated the area. Giovanni da Verrazzano is credited with 'discovering' the land, but recognition goes to Capt. William Whittington for acquiring from Lord Baltimore the patent for 1,000 acres in 1771. In 1872, a group of five men, having formed the Atlantic Hotel Company Corporation, approached the then owner of the island, Stephen Taber, to buy 10 acres to build a lodging facility, which came to be known as the Atlantic Hotel. Through the selling of lots valued at $25 each, Ocean City began to take root as a coastal resort, with the help of the railroad that ran from Salisbury to the bay. July 4, 1875, is struck as the town's official founding date.

Ocean City has changed since its inception, but much of its philosophy—family ownership, clean beaches, and fine hospitality—has remained. The city's early slow growth had been attributed to a lack of accessibility, but, over time, transportation improved, the boardwalk was built and expanded, and the city's limits stretched beyond the original 10 acres. Human ingenuity germinated greater creature comforts, sprouting boardinghouses, cottages, hotels, motels, amusements, dining and dancing, and a host of other tourist-oriented activities and businesses. Post-war booms and the building of the Chesapeake Bay Bridge brought hordes to the vacation spot. Property values escalated, then increased again, and again. The original investors and their descendants in Ocean City have made profits thousands of times over.

From cattle grazing in the mid-1800s to a few blocks of buildings at the turn of the century, from the construction of better transportation systems in the 1920s to the infamous fire, 1933 storm, and whopping growth in the 1940s, the city has been a resort to contend with. The 1950s saw the laying of new streets and the widening of old ones, the fashioning of an airport, and the beginning of deep-sea fishing. The 1960s brought population and real estate surges, land annexations, new and improved infrastructures, trailer parks, destruction from another storm, and the creation of such organizations as life saving and beach patrols. The 1970s witnessed the largest expansion, with the inception of the Ocean City Life Saving Museum and the headlining of condominium row. The 1980s brought clamming, luxury townhouses, and re-zoning policies for a small town that now laid claim to being one of the densest resorts in the country. The resort in the 1990s saw improvements and refinements as well as the razing of some of the old buildings and the development of many of the new. The millennium will behold a $3.5 million boardwalk renovation and expansion.

There is no end to Ocean City's growth as more and more families discover this delightful gem that welcomes casualness and offers relaxation and amusement. The success of the island's growth depends on its politicians and business people to properly plan, maintain, and forge ahead. So far, the little funland and its people have done a grand job of it.

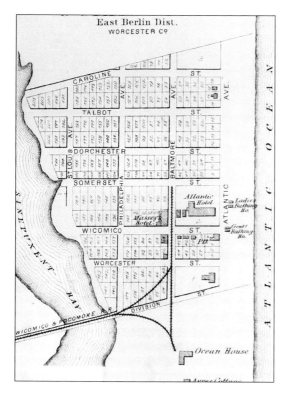

This map of Ocean City is from the 1877 atlas of Wicomico, Somerset, and Worcester Counties. The railroad entered Ocean City at South Division Street, and North Division Street was the northern boundary of the town. The east-west streets were all named for Eastern Shore counties and the north-south streets named for large cities. The Massey Hotel became the Seaside. The Ocean House and Ayers Cottage are south of the town but reachable from the railroad tracks. The railroad tracks ran only to Somerset Avenue then, but were extended past Talbot later on. There was no boardwalk yet except for the moveable sections laid on the sand by hotel owners.

One

TRAIN TRAVEL
AND BRIDGES

When Ocean City was founded in 1875, the only way to visit was by private carriage to Sinepuxent Bay and then by ferry across the bay. In 1876, the Wicomico and Pocomoke Railroad built an extension of its line to Berlin and a low-trestle bridge across the Sinepuxent, allowing wood-burning locomotives to chuff their way into Ocean City. Initially, tracks were laid to run up Baltimore Avenue to the Atlantic and Seaside hotels, then the train had to back down Baltimore Avenue far enough for the engine to swing left and go back across the bridge. Since there was no other bridge into Ocean City, planks were put on the bridge so pedestrians, wagons, carriages, and, later, automobiles could cross by paying a toll of 5¢ per wheel (a pedestrian counted as one wheel). In 1908, Worcester County made a deal with the Baltimore, Chesapeake and Atlantic Railroad (successor to the Wicomico and Pocomoke) to pay $1,250 per year in lieu of tolls and to permit alternating one-way crossing of the bridge.

The first coal-fired locomotive arrived in Ocean City in 1893. The BC&A, more familiarly known as the Black Cinders and Ashes, ran excursions on the weekends from Claiborne to Ocean City. The train met a boat from Baltimore and made a high-speed run to Ocean City, leaving the excursionist approximately two hours in Ocean City. Railroad service to Ocean City terminated when the railroad bridge was washed away in the storm of 1933 and was not rebuilt.

Bridges have also been a fascinating topic for Ocean Cityites, from the railroad bridges to the earliest state road bridge, to the present four-lane bridge, and now a second bridge in Ocean City and one in Fenwick. We deal here with only the first and second state road bridges.

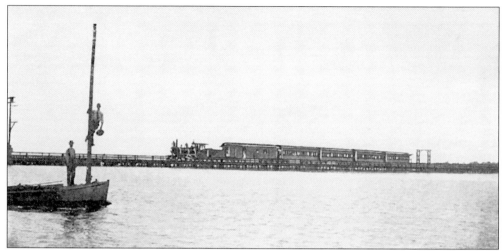

TRAIN CROSSING SINEPUXENT BAY. This is the earliest card; it was made prior to 1907. The train is pulling a baggage car, three passenger cars, and a mail car. Note the two towers behind the train. At that time there was a drawbridge for boats, and the towers were used to support the counter weights when the bridge was opened.

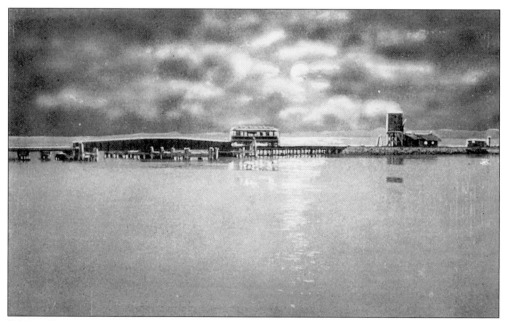

BC&A BRIDGE ACROSS SINEPUXENT BAY. This scene shows the pivot bridge with its narrow opening that could be difficult to navigate if you were, for instance, in a sailboat in a stiff breeze. The picture also shows a bus crossing the bridge. In this picture there is no waiting but one can imagine a Sunday afternoon at train time and a line of traffic waiting to cross both ways.

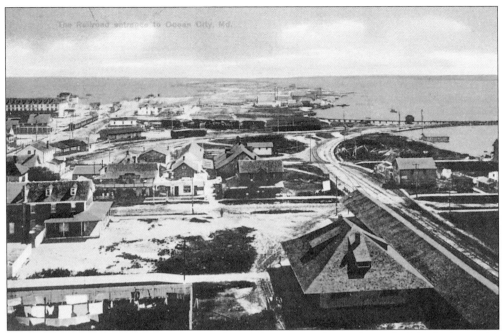

THE RAILROAD ENTRANCE TO OCEAN CITY. This picture shows the end of the bridge at the far right. The tracks curve sharply left and go past the freight station, then reach Philadelphia Avenue at Talbot Street (not shown). The return tracks leading to the bridge are visible in the background. (Courtesy of David Dypsky.)

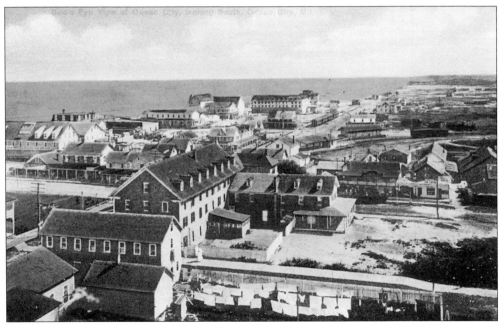

BIRDS-EYE VIEW OF OCEAN CITY. This and the scene above overlap. Wicomico Street crosses the scene from left to right. The Seaside Hotel is shown in the center, and the steam laundry is north of it. Baltimore Avenue runs down to the bay. The Hotels Belvidere and de Cropper are at the top on the left. (Courtesy of David Dypsky.)

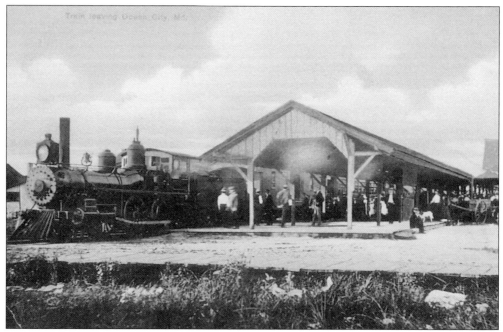

TRAIN LEAVING OCEAN CITY. These two-wheeled carts were dispatched by each hotel to the station to haul guests' luggage to their hostelry. Each cart was under the sign of its hotel, and each porter had a list of those with reservations. The guest had to walk to his hotel, but he carried no luggage. In this picture, dated 1908, the street is unpaved.

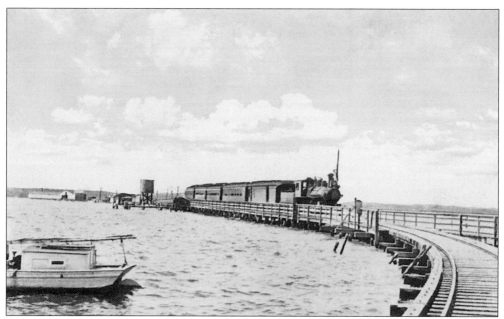

TRAIN CROSSING BRIDGE. In this picture, the planking of the bridge shows clearly. The planks are close to each other but do not abut. This would make a rough ride in an automobile.

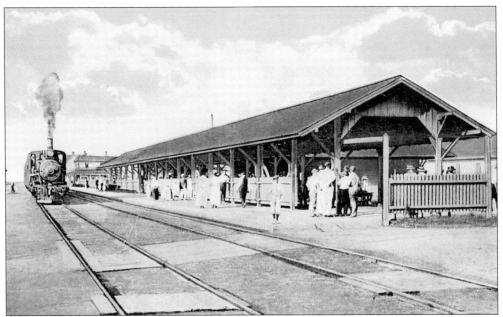

BC&A RAILROAD STATION. This shows the passenger station on the other side of the tracks with the train backing down to head out.

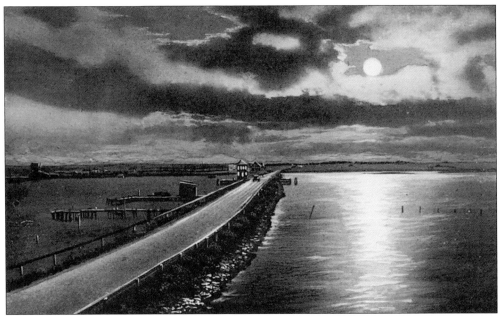

NEW STATE ROAD BRIDGE BY MOONLIGHT. It is after dark and, fittingly, only one automobile is on the bridge, but lights on in the bridge tender's house show that the bridge was manned around the clock.

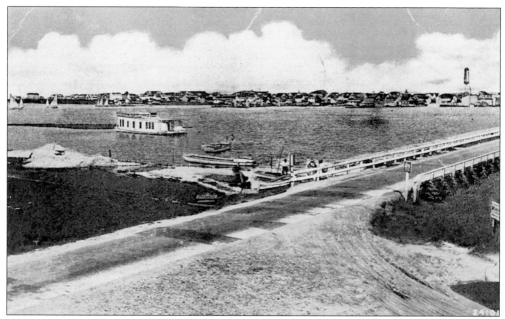

SINEPUXENT BAY. This picture was taken around 1930 and is postmarked the same year. It shows an approach but has no stop sign. The dirt piles to the left show the first effort to build on land on the north side of the bridge. (Courtesy of David Dypsky.)

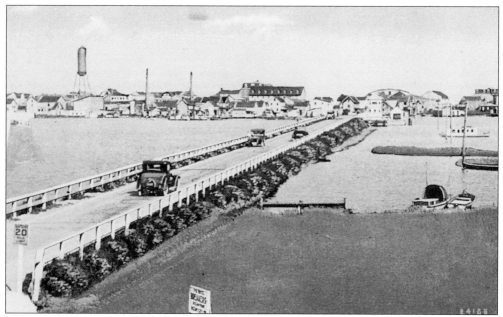

STATE ROAD BRIDGE APPROACHING OCEAN CITY. Built in 1916, the first state road bridge crossed to Worcester Street in Ocean City. Notice the speed limit sign cautioning 20 miles per hour, the sign for The Breakers Hotel, and the bridge tender's house. This card was mailed in 1933.

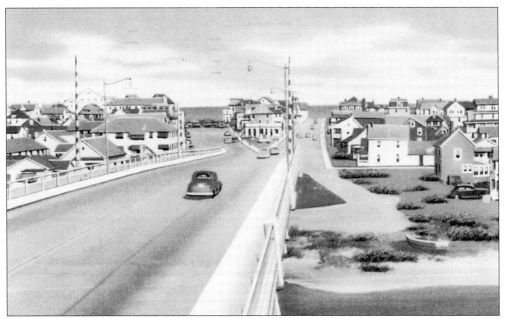

ENTERING OCEAN CITY. This image, dated 1952, appears on the reverse of the preceding postcard. There is no light at Philadelphia Avenue to stop the incoming traffic and none to regulate the traffic heading south. The right turn visible at the foot of the bridge was used to cross under the bridge to take St. Louis Avenue north.

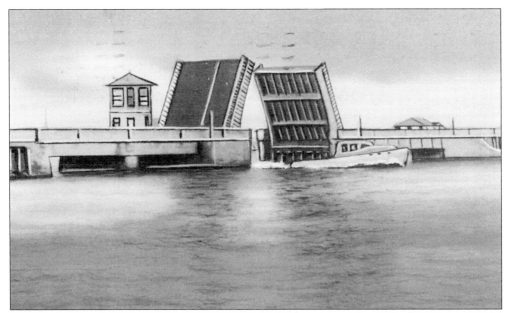

FISHING BOAT PASSING THROUGH DRAWBRIDGE. In this image, postmarked in 1946, one can see how low the bridge was built and how the passage of any boat required the drawbridge to be opened. As traffic increased, the wait on the bridge due to boat traffic became a sore spot for motorists. This is the second bridge built in the 1940s.

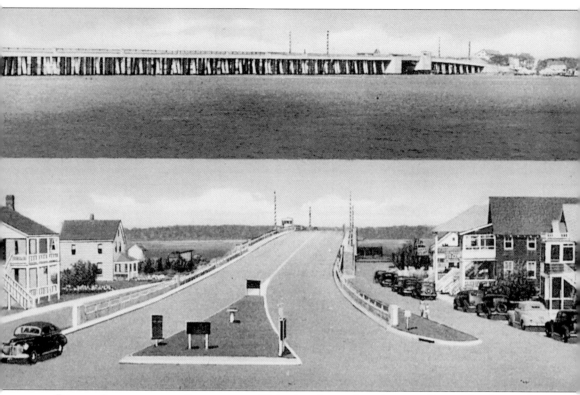

BRIDGE SPANNING THE SINEPUXENT. This view shows the split in traffic on the Ocean City side of the bridge. This is the new bridge with one-way traffic to the bridge off Philadelphia Avenue and one-way also for incoming traffic. This card is postmarked 1946.

Two

SEA, SAND, AND SKY

Tons of clay and topsoil have been brought into Ocean City to transform it into the city it has become since its founding a century and a quarter ago. In 1875, it was a wind-swept barrier island; it is now, in the summertime, the second-largest city in Maryland. This chapter takes a look at the start of this transformation.

The first hotels and houses were built on pilings—wood preserved by use of chemicals. The pilings soon began to rot. The basements were built of block, and a concrete floor was poured, with the sand from the footing excavations thrown inside to raise the floor level a few inches above the outside level. Many remember standing underneath the boardwalk with plenty of head room and the next year not being able to do so. At one boardwalk hotel a tenant was asked to remove 3 feet of sand from his basement area before the hotel could be used for the summer season. The ocean was not always friendly.

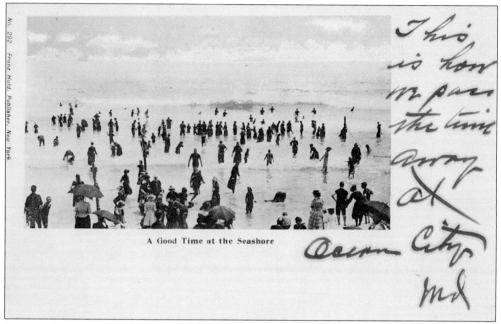

A GOOD TIME AT THE SEASHORE. This card is dated 1905. Back then, bathing was about the only thing to do at the beach except in the evenings when one could play whist.

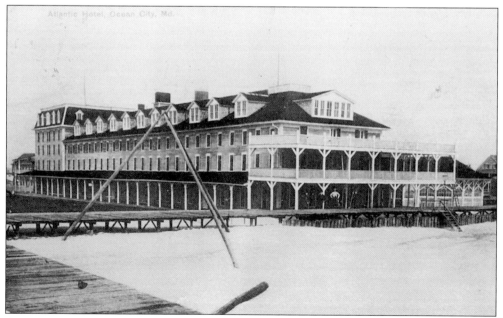

ATLANTIC HOTEL. This hotel was the first one built in Ocean City, but the picture was taken after a permanent boardwalk was built. At lower left is a ramp on Wicomico Street leading down to the beach. The car park to the left of the hotel is empty. This card is dated 1911.

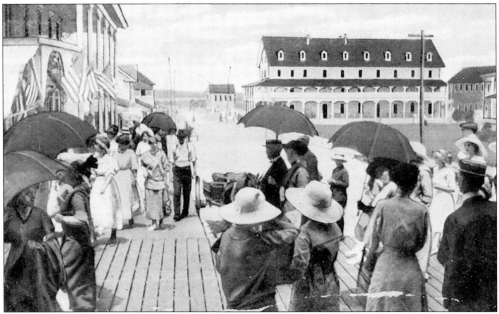

LOOKING FROM THE PIER. This card shows the Seaside Hotel; the edge of the Atlantic Hotel is on the right and the hotel on the left is the Belvidere. The raised umbrellas do not mean it was raining, but only indicates that the parasol had not come into common use yet.

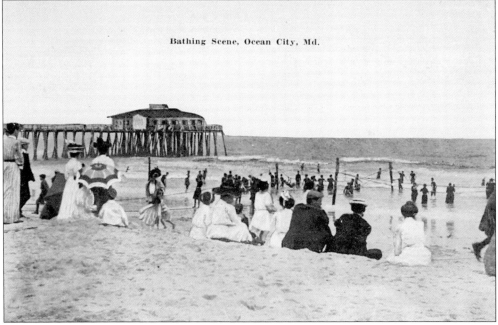

Bathing Scene, Ocean City, Md.

BATHING SCENE. The pier, begun in 1907, is visible in this picture, but you can see it did not extend very far into the water. A rope has been strung out into the water for use as a hand-hold for bathers, and the line of poles to which it is attached can also be seen. The last pole is at the water's edge, and the rope is somehow anchored on the bottom. The women on the sand are seated on blankets, not beach towels. This postcard was mailed in 1910.

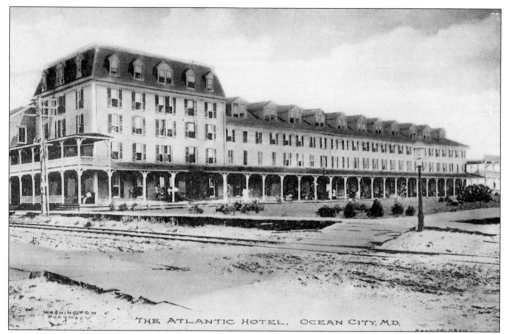

THE ATLANTIC HOTEL. This *c.* 1910 picture shows the railroad tracks on Baltimore Avenue and the hotel before the car park was installed. The railroad tracks were laid in the middle of the street, which was unpaved. The sidewalk shows significant holes where it crosses the railroad tracks.

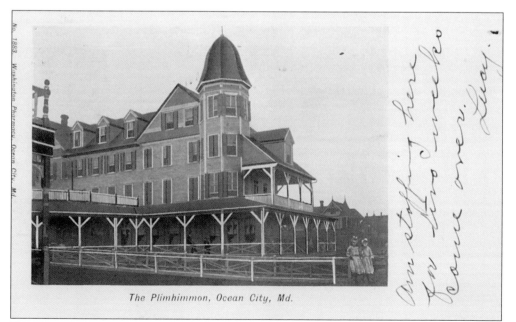

The Plimhimmon, Ocean City, Md.

THE PLIMHIMMON HOTEL. The hotel was built by Rosalie Tilghman Shreve, a great-granddaughter of Col. Tench Tilghman, aide-de-camp to George Washington. Built in 1893, the hotel had an imposing tower at the southeast corner. The dome was preserved when the hotel burned and has been put on the hotel's modern replacement.

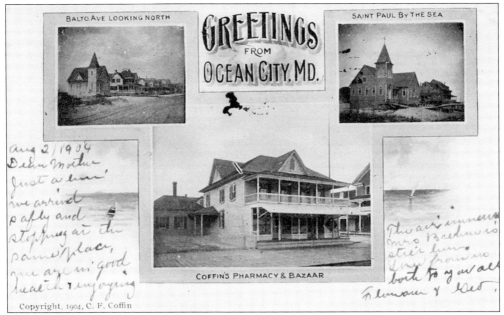

GREETINGS FROM OCEAN CITY. C.F. Coffin had a pharmacy and a bazaar in the building shown in the center of this card; he had postcards made and sold them under his copyright as early as 1904. The Presbyterian church and the Gables, the hotel next to it, are shown at the upper left and St. Paul by the Sea is at the upper right.

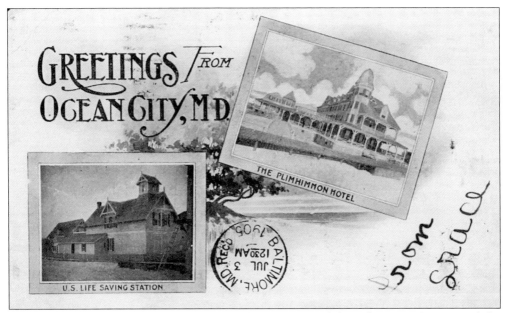

GREETINGS FROM OCEAN CITY. On this card are pictures of the Life Saving Station and the Plimhimmon Hotel. Coffin varied the pictures on each greeting card bearing his imprint.

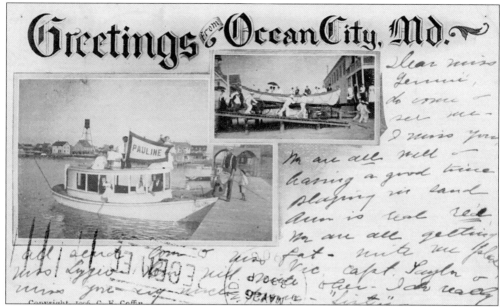

GREETINGS FROM OCEAN CITY. On this 1906 card, Coffin pictured an early cruise boat named *Pauline* in the Sinepuxent. Men wheel a lifeboat down the ramp to the beach; two men pull and three men push.

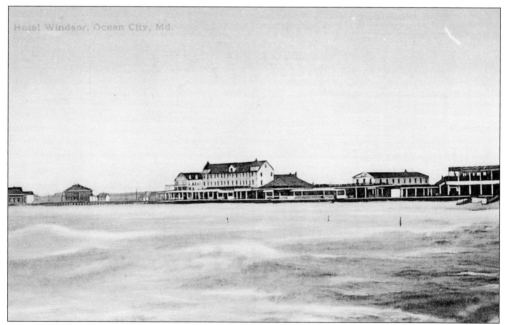

HOTEL WINDSOR. This 1909-dated card shows the Hotel Windsor as well as the whole south end of the boardwalk. The Windsor is the three-story building, but the rest of the buildings make up Luna Park, which was founded by Daniel Trimper. Trimper bought two whole blocks that still belong to his family.

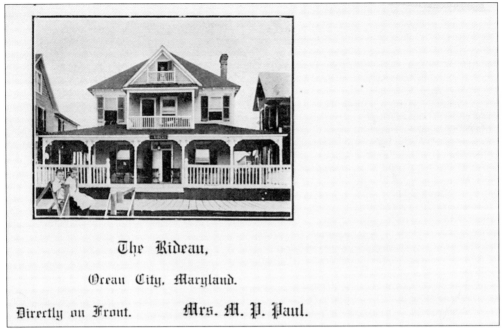

The Rideau,

Ocean City, Maryland.

Directly on Front. Mrs. M. P. Paul.

THE RIDEAU. This picture shows the original hotel, which was "Directly on Front." Notice how narrow the 'front' was at that time. Mrs. Paul was one of the 'pioneer women' who owned or ran a hotel in Ocean City.

THE HAMILTON HOTEL. Posted around 1906, this card shows that the hotel was built on the north corner of Third Street in 1901. The structure was only partially complete when it was bought by Mrs. Josephine Lewis Massey. When completed, it became famous for its fine food; it also had an orchestra to play for guests at midday and at evening meals. The hotel burned to the ground in 1969.

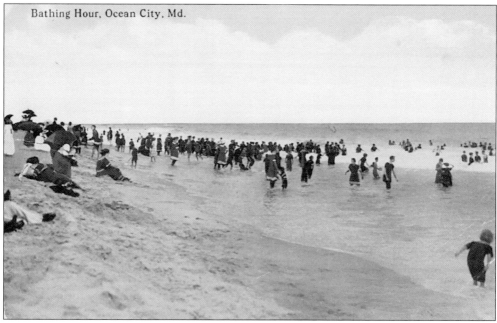

Bathing Hour, Ocean City, Md.

THE BATHING HOUR. At the bathing hour, which began at 11 a.m., men, women, and children streamed out to the beach, all dressed appropriately for bathing in the surf. This scene changed dramatically when it became time for the midday meal. This is a c. 1916 view.

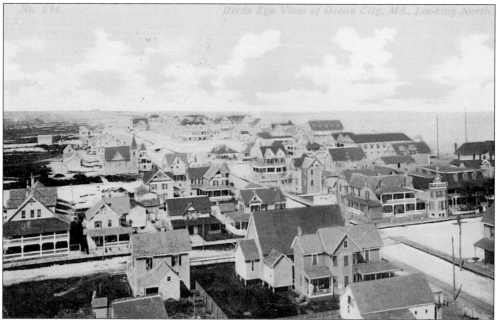

BIRDS-EYE VIEW OF OCEAN CITY, LOOKING NORTH. Construction was not exclusively on the boardwalk. Baltimore Avenue is at left and runs diagonally across this image, and Talbot Street runs from right to left in the foreground. The first Catholic church is on Baltimore Avenue and Talbot, and the building to the south of it is the rectory. The Presbyterian church is on Baltimore and Division Streets with the Gables to the north of it. The Isle of Wight Hotel is on the northeast corner of Baltimore and Talbot.

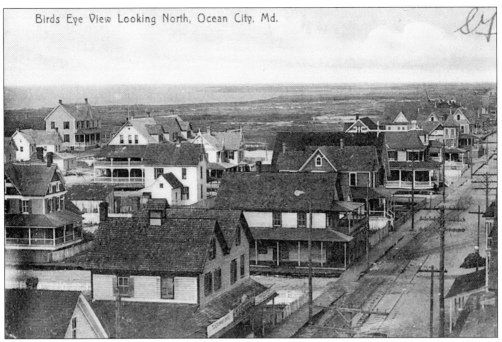

BIRDS-EYE VIEW, LOOKING NORTH. In this postcard marked 1907, Baltimore Avenue is on the right side. The Catholic church can be seen with the cross on top of the building, and the rectory is again south of it. Dorchester Street is in the foreground, and the railroad tracks stop just north of Dorchester Street. The sign at the bottom of the picture is for T.J. Cropper's store.

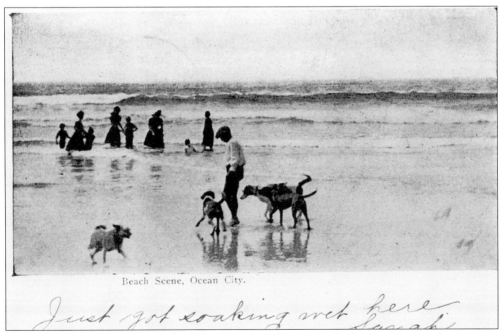

Beach Scene, Ocean City.

BEACH SCENE, OCEAN CITY. The long dresses on the women bathers were normal swimming costumes in 1907. Although pets were allowed on the beach back then, it's taboo today.

27

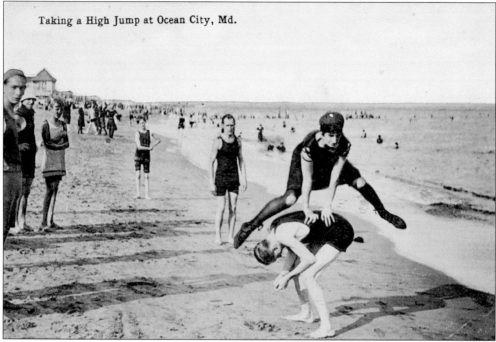

Taking a High Jump at Ocean City, Md.

TAKING A HIGH JUMP AT OCEAN CITY. The time is 1913 and the skirt is now at knee length, but women are still wearing stockings. The woman leap-frogging in this photo is more active than most women of the time. The men wore one-piece suits with an attached short skirt.

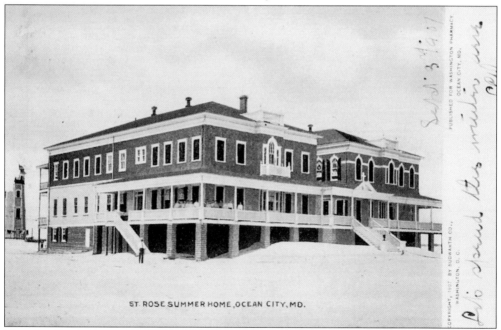

ST. ROSE SUMMER HOME, OCEAN CITY, MD.

THE ST. ROSE SUMMER HOME. This building, located at Fourteenth Street and Baltimore Avenue, was built in 1898 as a home for orphans and was run by the Sisters of Charity of Washington, D.C., for 13 years. It was finally sold to the Dominican Fathers of Catholic University. The building resembling a lighthouse tower in the rear was the water cistern.

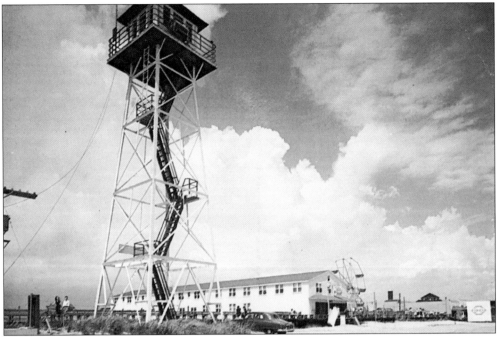

THE COAST GUARD LOOKOUT TOWER. Since it was first built, this tower served a vital purpose for seafarers.

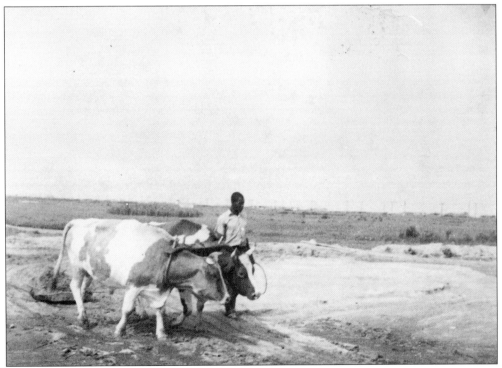

ROAD CLEANING. Equally important as the sea and sky were the roads. Here is an image of a man and his oxen smoothing and filling in the sand to create a roadway in 1936. (Courtesy of W. Quigley Bennett.)

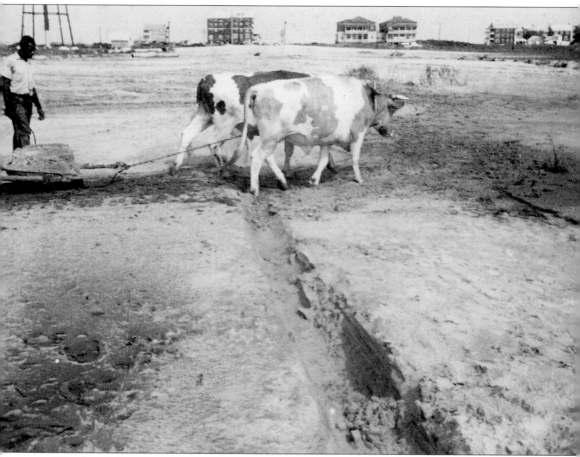

THE LAST APPEARANCE. This picture shows the use of oxen in Ocean City near the inlet for leveling sand in preparation for road construction around 1936. It is probably the last appearance of oxen in Ocean City. (Courtesy of W. Quigley Bennett.)

Three

SEAFARING

The Life Saving Service was established by Congress in 1875, and a station was built in Ocean City in 1878 where a keeper and six surfmen were assigned. Sleeping quarters were provided at the station. The men assigned there were to patrol the beach on foot and on horseback, to maintain a lifeboat in constant readiness, and to watch the sea from a tower on the station. For rescues from ships that had gone aground near the shore, a cannon was maintained to shoot a line to the distressed ship and then send a breeches buoy out to the ship and haul the crew ashore. The station was located on the south side of Caroline Street on land provided by Stephen Taber, who had owned the land on which Ocean City was built. The Life Saving Service was merged into the Coast Guard in 1915.

Many a sailor and fisherman relied on lifesaving techniques, and pound fishers were no exception. Pound-net fishing was a dangerous way to earn a living. A captain and six men formed a boat crew. They had to launch a 40-foot strake-sided boat from the beach, get aboard it, row it out to the pound, pull up the net, dump the fish into the boat, then row it back to the beach through the surf, haul the boat ashore, and help to unload it. The crew tied a rope to a piling offshore to help guide the boat in to land and on to the wooden rollers that they had left there. The fish pounds were created by settling about 24 poles in the ocean floor with a net strung between the poles to form a trap about 40 feet square with a funnel-shaped opening. A weir stretched across the current for about 700 feet to direct the fish in to the trap. The men who worked in this profession lived in camps and ate meals provided by a fish company.

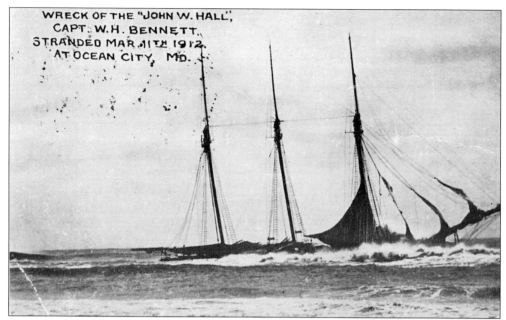

WRECK OF THE "JOHN W. HALL",
CAPT. W. H. BENNETT,
STRANDED MAR. 11TH 1912.
AT OCEAN CITY, MD.

WRECK OF THE JOHN W. HALL. This is a c. 1912 picture of an actual wreck. The vessel has been broached and only the mainsail on her foremost shows any canvas. A breeches buoy would have been used to bring the crew ashore.

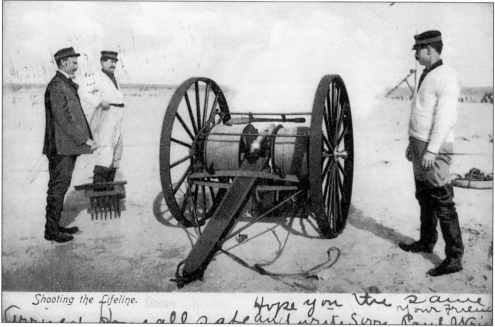

Shooting the Lifeline.

SHOOTING THE LIFELINE. This shows the two reels, one with the light line, the other with the heavy line. Crew members had to affix the two reels to a mast so the man coming ashore in a breeches buoy wouldn't sag into the sea on his way.

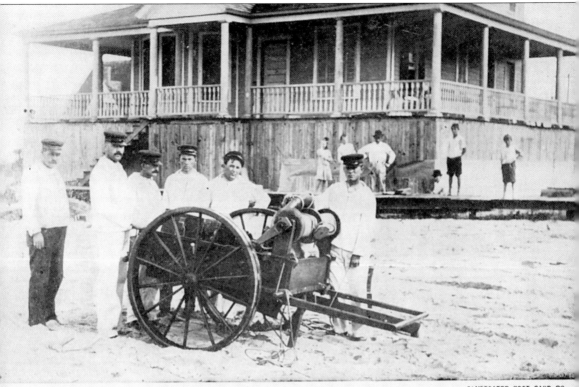

GETTING READY TO DRILL THE GUN, OCEAN CITY, MD.

GETTING READY TO DRILL THE GUN. The cannon would shoot the line through the boat's rigging, the crew would catch it and secure it, then a heavier line would be hauled to the vessel, and the breeches buoy could be sent from the beach.This gun had to be manually hauled by the surfmen to a point opposite the stranded vessel. The Coast Guard eventually developed a simpler way to drill this exercise. They erected a mast at their station on Caroline Street, affixed a spar near the top of it, and every Saturday morning they would haul their Lyle gun out to the corner of Baltimore Avenue and send a member of their crew up the mast. They would fire the gun and throw a line over the mast and yardarm. The crew man would retrieve it and haul on the line until he got the heavy line, then the rest of the crew would send a breeches buoy up to him. Sticking his legs through it, the "rescued" man waved to the assembled children as he was hauled back to ground level.

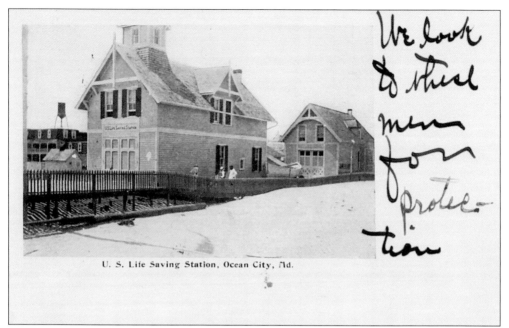

U. S. Life Saving Station, Ocean City, Md.

U.S. LIFE SAVING STATION. This *c.* 1905 image shows the original station as it was built on the corner of Caroline Street and the boardwalk. The new station was built in front of it in 1897. The message on the card is evidence enough of the feeling among the public about the life savers' jobs.

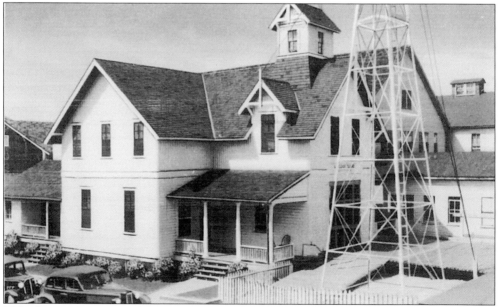

U.S. COAST GUARD STATION. This 1940 image shows the station after it was rebuilt. The towers, the double windows on the side, and the double doors were part of the original building, but the rest is new, including the middle tower in the yard. This picture was taken after the Life Saving Service's amalgamation with the Coast Guard.

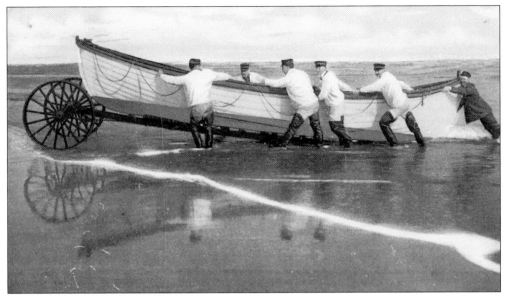

BRINGING IN THE LIFEBOAT. Long practice enabled the surfmen to center the boat, push it out of the water and up the rollers, and then pull the trailer ashore. They acquired better equipment later on. This card was dated 1905.

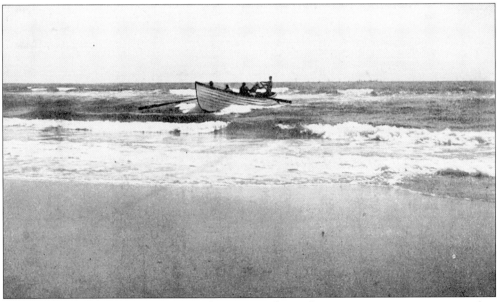

COMING THROUGH THE BREAKERS. This picture shows the coxswain attempting to catch a wave to bring the boat to the beach. He needs the lift of a wave to keep the boat from broaching. This card was mailed around 1913.

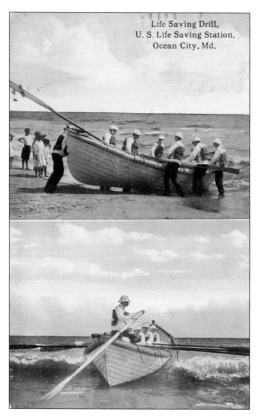

Life Saving Drill,
U. S. Life Saving Station,
Ocean City, Md.

LIFESAVING DRILL. This picture, dated back to 1913, shows a boat being launched using the oars to lift it. The captain uses the long steering oar, and three men on each side of the vessel also man the oars.

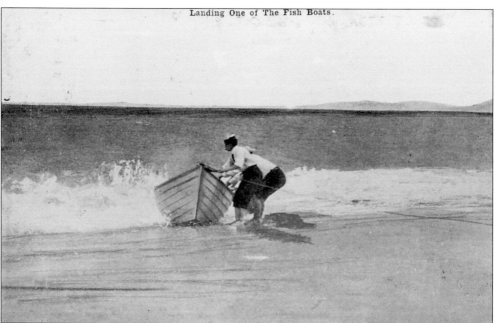

Landing One of The Fish Boats.

LANDING ONE OF THE FISH BOATS. This card shows a small boat. Except for the postmark that indicates Ocean City, one might wonder about the authenticity of this card, particularly because of the view of mountains in the background.

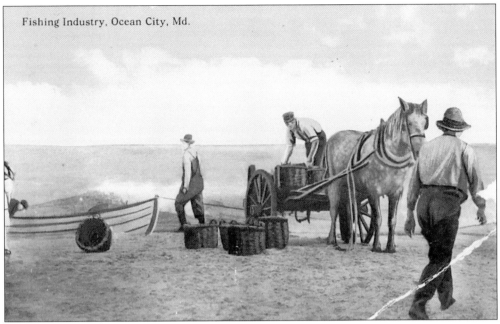

Fishing Industry, Ocean City, Md.

FISHING INDUSTRY. This card shows the fish baskets into which the catch was loaded. The man in the boat is probably scooping part of the catch into another basket.

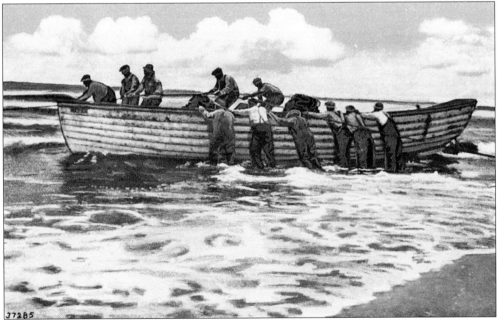

J7285

FISHING BOAT READY FOR A HAUL. The men in this powerboat are helping to hold the boat steady while the three men in the bow haul in the line to shore. This seems to indicate that they are in possession of a heavy cargo of fish.

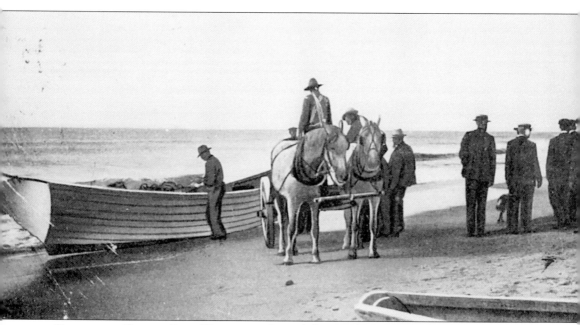

FISHING AT OCEAN CITY. This postcard, mailed around 1905, depicts a typical boat of the times. Notice that it is not a powerboat and there is a roller under her stern. These fishermen need a two-horse team to haul their catch off the beach.

Four

BEACH AND BOARDWALK

The beach scene and boardwalk change from year to year and month to month. Wind and waves combine in different ways to alter the beach, and jetties have also played a part. Bathing costumes have become scantier, and animals are now barred from the beach. Beach replenishment programs have changed the landscape, litter has become a problem, and lifeguards have worked to make the beach safer. Through postcards, many of these changes and developments have been recorded.

The boardwalk was for strolling. Children who ran quickly down the planks were forgiven, but adults who hurried were regarded with annoyance and stern disapproval by those around them. Wicker rolling chairs and their occupants were looked upon with the benevolence accorded the aged and infirm. Dawdling was permissible but not encouraged.

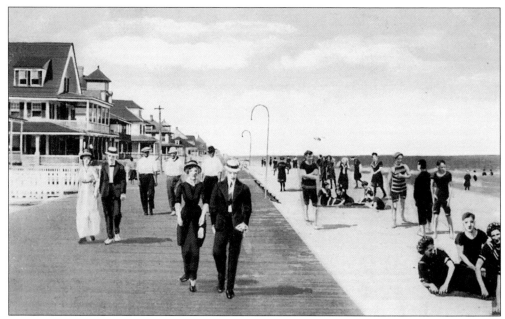

BOARDWALK AND COTTAGES. This card illustrates the proper pace and attire of the period, c. 1910. Notice the Victorian-style cottages in the background.

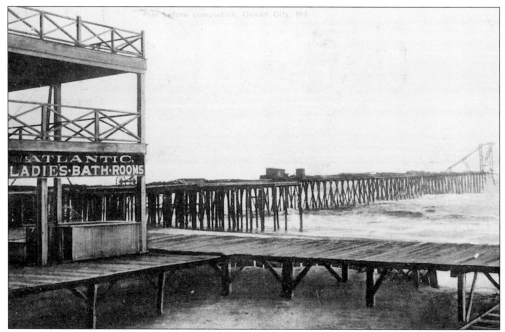

PIER BEFORE COMPLETION. At left are the ladies' changing rooms of the Atlantic Hotel, with a two-level porch. The pilings are close together at shore level, and this is where the buildings would be built. Notice the cross bracing of the pilings part of the way out. This card was mailed on September 4, 1907.

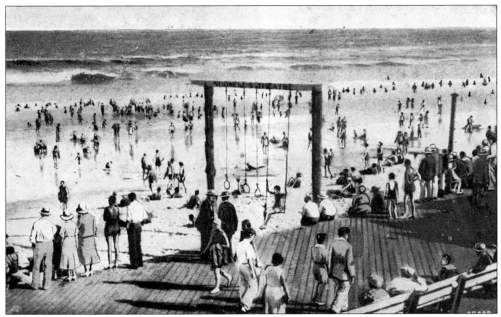

BATHING SCENE. The rings and the swing present on the beach around 1925 were provided for exercise. Only the surf now provides exercise for the public. Notice the angle of the planks on the boardwalk and compare it to the previous picture—the angled boardwalk was sturdier.

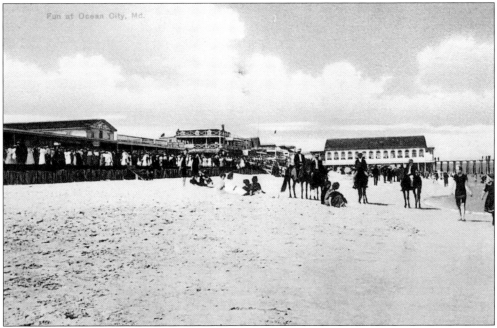

FUN AT OCEAN CITY. The pony rides on the beach were provided by William B.S. Powell and Joe Hickman at a charge of 10¢ per half-hour. John E. Jacob remembers riding them when his legs could not reach even the shortened stirrups; he had to put his feet between the leather straps on top of the stirrups.

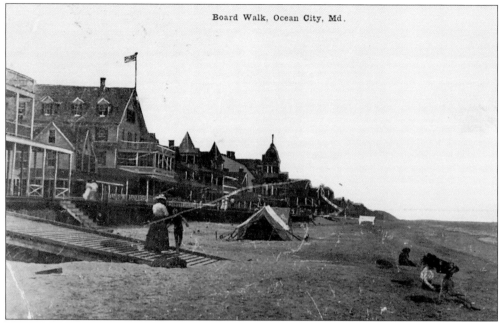

Board Walk, Ocean City, Md.

BOARDWALK, C. 1911. To the left is a ramp leading down to the beach at a street corner and the stairs of the building next to it. What is most notable in this image is the tent pegged down on the beach and what appears to be an advertising board in the background.

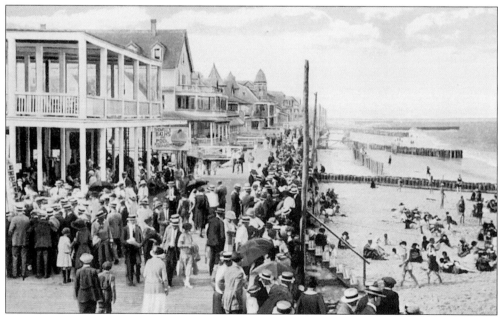

BOARDWALK, LOOKING NORTH FROM COAST GUARD STATION. The jetties, driven so close together, made walking for a mile on the beach almost impossible. It was like running an obstacle course. One could walk around the short jetties but not the ones that carried ropes for the bathers. Showell Bath House and Pool is on the left of this c. 1920 view. Notice the crowd watching the swimmers in the pool.

FRIENDLY GIFT SHOP. The shop pictured here claims to be the largest jewelry and gift shop in Ocean City and boasts its reliability since 1934. The shop is located at 212 South Boardwalk next to Taylor Porkroll and across Dorchester Avenue from the Nordica Apartments. (Courtesy of the late Fred Brueckmann.)

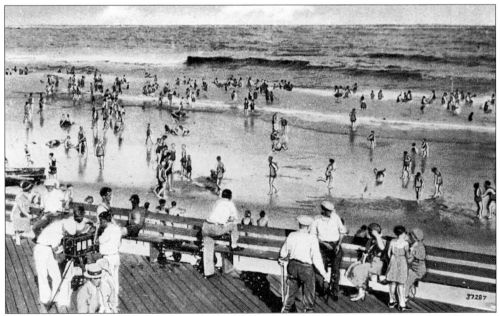

BATHING BEACH. This itinerant cameraman only worked in the daytime. When the long shadows of evening had gathered, his day was done. He has just taken a picture of the two young men standing by his camera; the three pictures on it probably served to entice them.

43

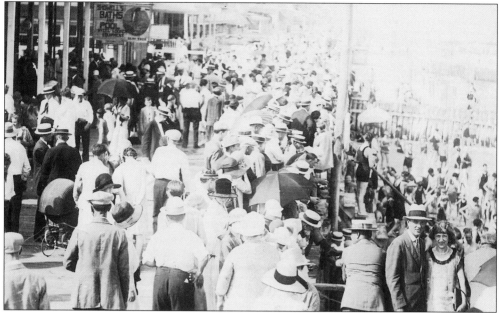

CROWDED BOARDWALK. This 1908-postmarked picture was taken of the couple on the lower right. The beach photographer left his print at lower left, pressed into the card; he was James Mitchell of Ocean City. (Courtesy of David Dypsky.)

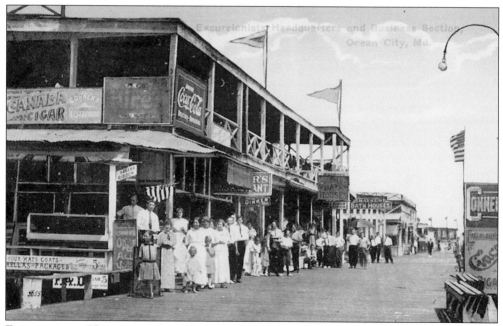

EXCURSIONIST HEADQUARTERS AND BUSINESS SECTION. This card takes you back to the train travel days, and the scene is George Conner's Restaurant. Conner advertised that hats, coats, umbrellas, and packages could be checked here for 5¢ apiece. He also advertised that the restaurant was open all night. Coal-fired trains made coats for men and women advisable because of the ashes.

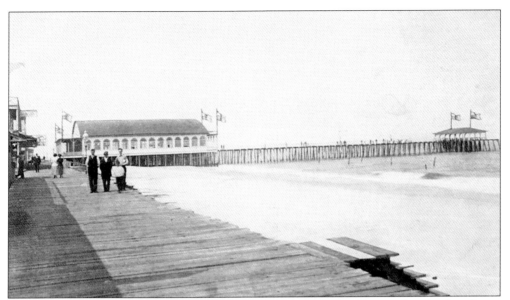

THE NEW OCEAN CITY PIER. The principal point of interest on this card is the fact that it was published by George B. Conner, who, in addition to his other services to tourists, provided postcards.

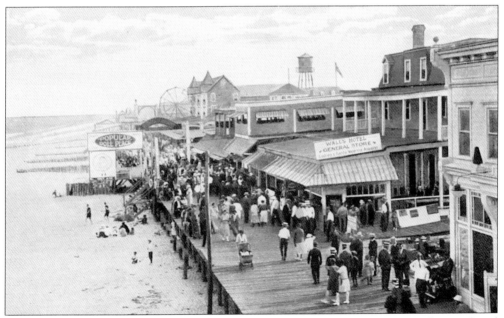

BOARDWALK, LOOKING SOUTH FROM OCEAN CITY PIER. The sign says "Walls Hotel and General Store Ladies and Gents Wearing Apparel." On the beach side of the picture is the "Popular Doll Place." Beyond it is the sign that tells you that you are entering Luna Park, D. Trimper, proprietor. Here, around 1910, women's dresses are about 10 inches off the ground.

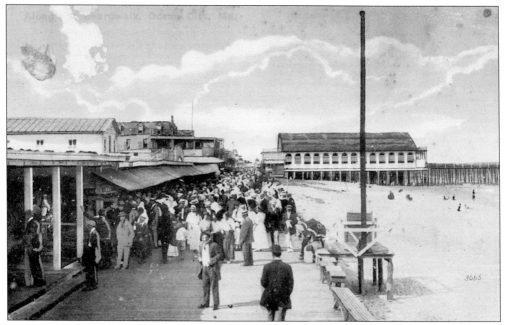

ALONG THE BOARDWALK. The pier has now been finished, and the crowd is solid right up to it. These people are staring into the stores but not spending their money.

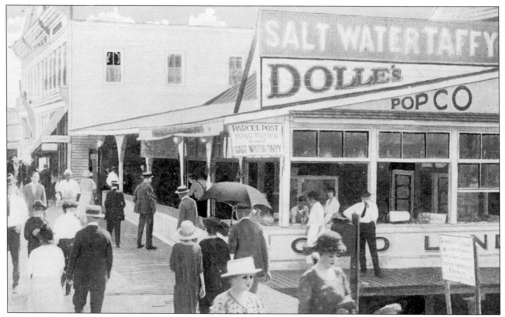

SUNDAY AFTERNOON IN FRONT OF THE PIER. Rudy Dolle came to Ocean City in 1905 and started making saltwater taffy. His family lived over his stand. This image was made before the fire of December 1925 that decimated three blocks of the boardwalk. Dolle's loss from the fire was valued at $7,000.

ENTRANCE TO OCEAN CITY PIER. This picture postcard, mailed in 1911, shows the original front of the pier. Its entrance was at least 5 feet above the level of the boardwalk, and that entrance only led one to the porch. The commercial establishments, if any, were behind the porch. (Courtesy of David Dypsky.)

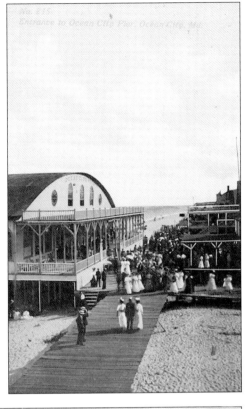

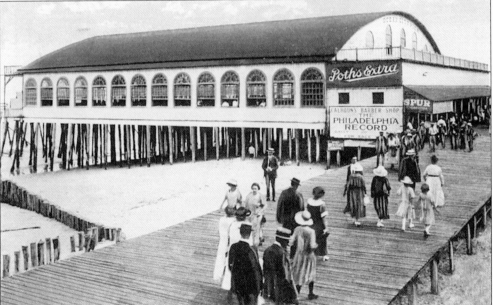

OCEAN CITY PIER. The advertisements on the pier are for Calhoun's Barbershop, where the Philadelphia Record is sold, and for Poth's Extra. The porch level has been dropped to Boardwalk height and covered in. The squib on the back of the card reads "Here one may indulge in fishing and other interesting sports."

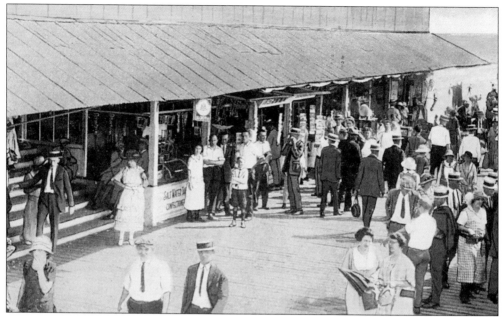

JESTER'S SOUVENIR, CONFECTIONERY, AND LUNCH PAVILION. The pier steps are pictured at left, and the sign next to the steps advertises saltwater taffy. Could this be where Rudy Dolle got started? Both stores are open-fronted, but Jester's shop occupies only the south half of the pier.

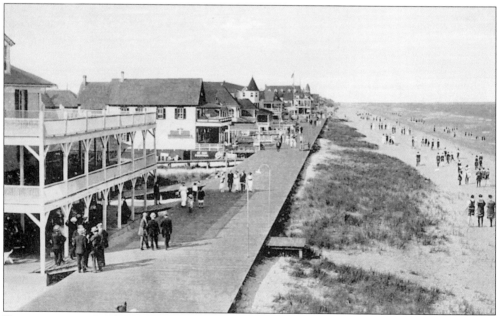

BOARDWALK FROM OCEAN PIER. This view shows the Atlantic Hotel on the left; notice that the level of the first floor is below the boardwalk. Next to the hotel is the Washington Pharmacy, which would later be known as Townsend's Drug Store. The Plimhimmon Hotel is in the distant background.

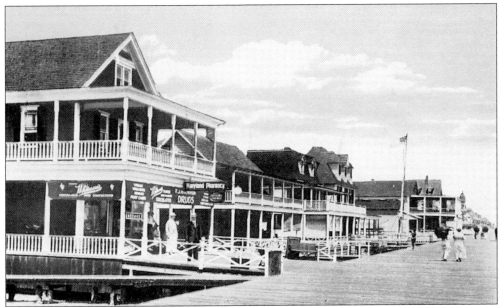

THE WASHINGTON PHARMACY ON BOARDWALK. This picture depicts the Maryland Pharmacy, located on the corner of Talbot Street, though the sign says F.J. Townsend Drugs. The sign also advertises postcards for sale. The Life Saving Station stands where the U.S. flag is flying.

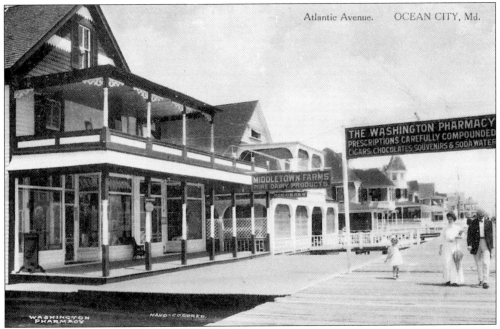

ATLANTIC AVENUE. This is a close-up view of the Washington Pharmacy with its advertisement across the Boardwalk that reads "Prescriptions Carefully Compounded, Cigars, Chocolates, Souvenirs and Soda Water." The other sign advertises "Middletown Farms, Dairy Products and Ice Cream."

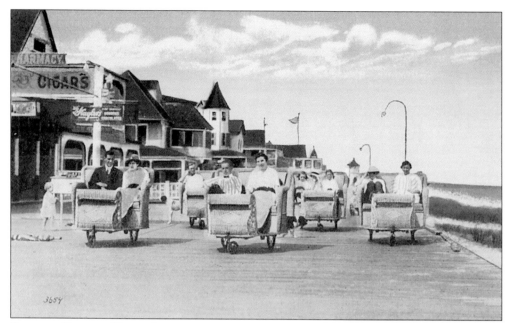

ROLLING CHAIRS. These chairs were a concession operated by Dr. Townsend and were kept in front of his drugstore. John E. Jacob, his sister, and his grandmother rode in the chairs; two small children and an adult could be accommodated. Jacob remembers that tongue-and-groove boards were laid over the top of the planking on the boardwalk for an easier ride and easier pushing. This picture does not show the pushers, but we assure you the chairs were not self propelled.

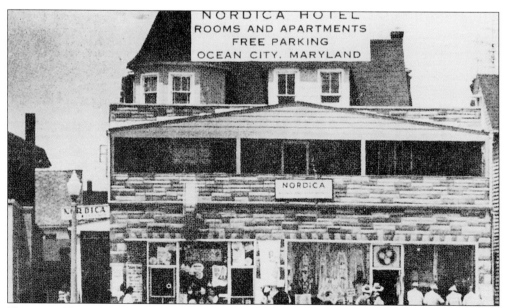

NORDICA HOTEL. Each room in the hotel boasted a washroom, and apartments included a shower and kitchen. The hotel's porch has since been replaced by shops, and the entrance is now on the side. The card contains two phone numbers; 33 is printed as part of the message and AT9-7151 has been added on a separate line at the end. (Courtesy of David Dypsky.)

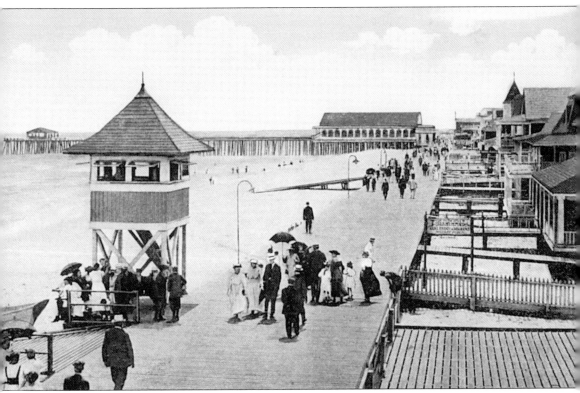

BOARDWALK AND PAVILION FROM LIFE SAVING STATION. This card shows the lifeboat on its trailer parked on the beach while the guard is on duty. The men in the Life Saving Service were not expected to swim; they used a boat for rescue missions. The lifeguards had only this one station, and, if you wanted the protection they afforded, you had to bathe in the ocean in front of the man on duty.

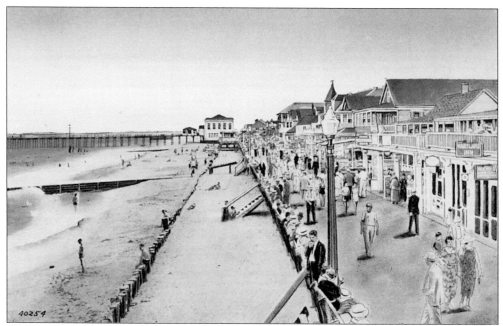

THE BEACH AND BOARDWALK, LOOKING SOUTH. The Maryland Inn is pictured at right in the 1920s. Since then, shops have taken over the area south of Caroline Street. The sign on the building south of the Maryland Inn advertises "near beer." Prohibition had arrived.

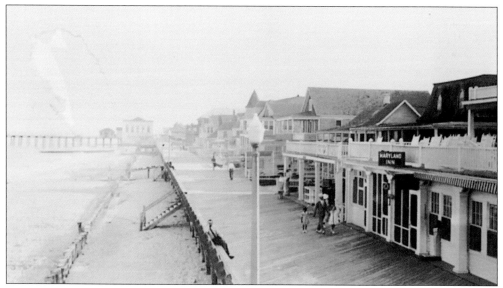

THE BEACH AND BOARDWALK, LOOKING SOUTH IN 1936. The only difference between this picture and the previous one is in the building next to the Maryland Inn. The porch roof has been built out to match that of the Maryland Inn, but the mansard roof is still visible. This structure was purchased and incorporated into the Maryland Inn, and the second floor of the Maryland Inn also incorporated in the combined buildings.

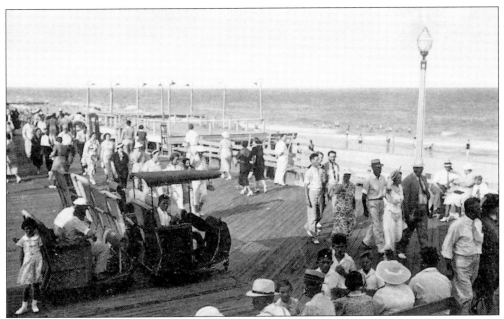

BOARDWALK. This card shows the bandstand as it was originally constructed, with lights for the musicians but no sound-reflective bandshell. Frank Sacca merits plaudits for his devotion to developing the Ocean City Marching Band. Take note of the two rolling chairs with the pusher resting inside each one as they wait for a fare.

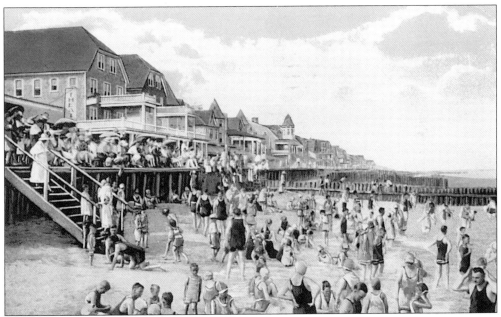

BEACH BOARDWALK FROM COAST GUARD STATION. This picture shows the boardwalk in the 1920s. The Mount Pleasant Hotel has been built and can be seen on the left. The movie theatre is down the side street, and the jetties have been built to protect the beach, which is very narrow. This image is postmarked 1935.

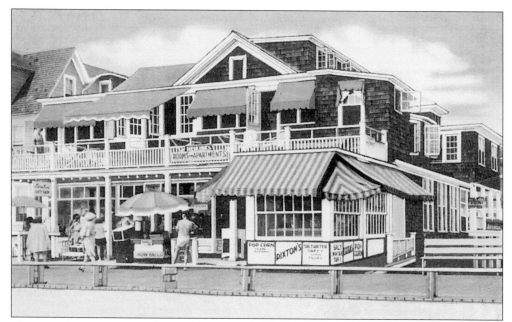

NEIKIRK APARTMENTS. This building is located on the corner of Talbot Street and the boardwalk. Fisher's Popcorn, instead of Pixton's, is now on the corner, and the other two shops have also changed tenants. The building has changed very little since the time of the one-cent stamp, which is called for on the reverse of this card.

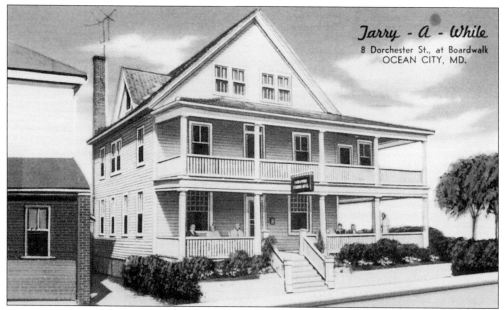

TARRY-A-WHILE. This is a beautifully maintained building; its exterior glistens in the sun. Except for the iron railings on the front steps that have replaced the wooden railing shown in the card, everything about the structure's exterior is the same. The building on the left is now occupied by the Bank of Ocean City. Tarry-A-While is owned and managed by Mr. and Mrs. Paul Morris.

Five

THE AMERICAN PLAN

Hotels, both large and small, upscale and ordinary, all served guests three meals a day, and did so since they were first opened. Some hotels featured good home cooking; some served elegant food with china and silver to match. A few establishments even provided live music at both lunch and dinner. All of these hotels offered a profusion of meats, seafood, fresh vegetables, baked goods, and desserts, and each had dishes on which they staked their reputations. The kitchen was king. Prices per week varied with the room accommodations and depended on the view: oceanfront, ocean view, or parking lot view. But all guests ate the same foods. The skill of the chef was more important than the elegance of the lobby and even more important than the comfort of the rocking chairs on the porch.

The reputation of the hotel owner was vital to his business, and, when a hotel's ownership changed hands, that reputation followed the owner to the new hotel. Today, that kind of reputation is only a memory carried chiefly by the children of former guests, by the local children of Ocean City who snacked at the various hotels, and by old timers who can no longer enjoy the rich foods they once ate at such hotels and rely on their personal recollections. The images of hotels in this chapter begin at the south end of the boardwalk and head north.

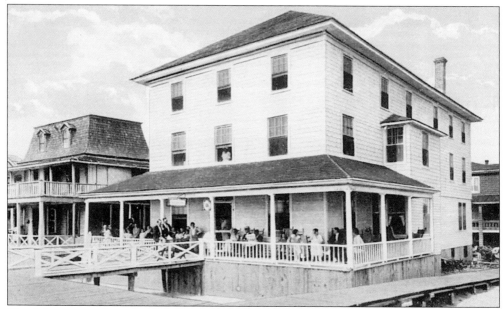

THE MARYLAND INN. The Maryland Inn, located at Caroline Street, was originally only a moderate-sized hotel opened by Louella Quillen Hagan and a partner. Hagan also managed to acquire the property next door and doubled the inn's size; she operated the hotel until her death in 1963. Hagan's children carried on her business after her death.

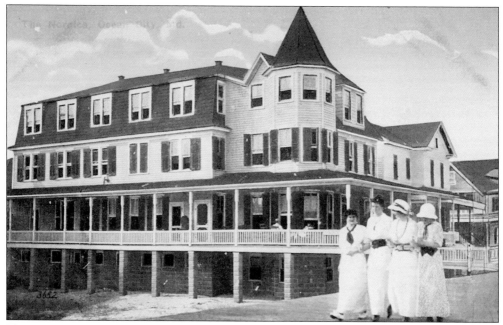

THE NORDICA. The Nordica, located at Talbot and the boardwalk, is an old hotel, as can be determined by the costumes of the strollers in this view. It gained the reputation of being a scary place because a reputed opera singer hanged herself from a chandelier in the hotel.

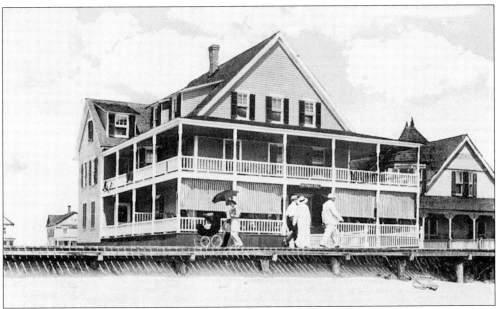

WETIPQUIN HALL. This hotel was built by a Harriet Dashiell in 1909. Miss Dashiell was descended from James Dashiell, whose family home was in Wetipquin in western Wicomico County.

THE ATLANTIC HOTEL. Located at Wicomico Street, this hotel was purchased by Dr. Charles Purnell in 1923 and was destroyed by fire in 1925. One section of the hotel was rebuilt in 1926, the second section the following year. The hotel was operated by the doctor until his death in 1961.

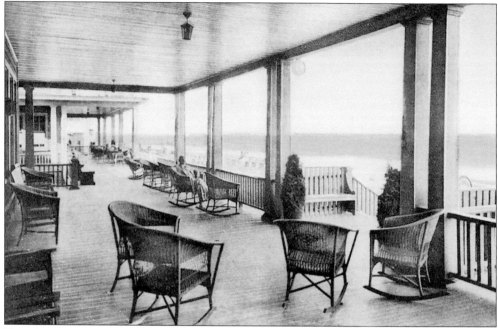

THE OCEAN FRONT VERANDA. After the second section of the Atlantic Hotel was rebuilt, this veranda linked the two sections. Furnished with the wicker rockers shown here, guests could rock to their hearts' content while observing the ocean and the passersby. Now only an entrance to the hotel is still preserved.

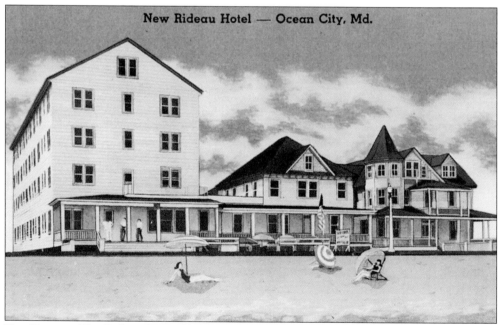

New Rideau Hotel — Ocean City, Md.

THE RIDEAU. The Rideau, located between North Division and First Street, started off small, but it has grown into three separate structures and is now a motor inn. It has also changed ownership over the years. (Courtesy of David Dypsky.)

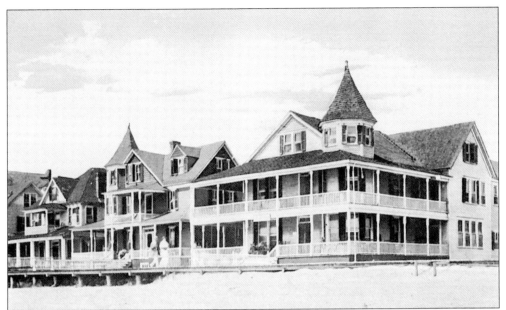

THE VIRGINIA AND LINMAR HOTELS. The Virginia was built by Minnie Moore, and the Linmar was built in 1908 by Minnie E. Newton. Newton's hotel was larger and more imposing than the Virginia. Both women were listed as pioneers in the centennial history of Ocean City.

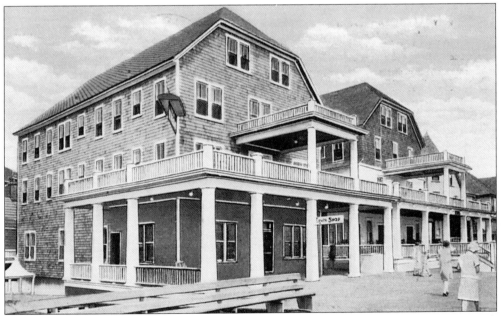

THE MOUNT PLEASANT HOTEL. Susan D. Mason bought the Mount Pleasant in 1918, and, when it was partially burned in 1923, she rebuilt it and doubled its size. Mason then named it the New Mount Pleasant. She sold it in 1932, and it was renamed the Roosevelt. It was destroyed by fire in 1970.

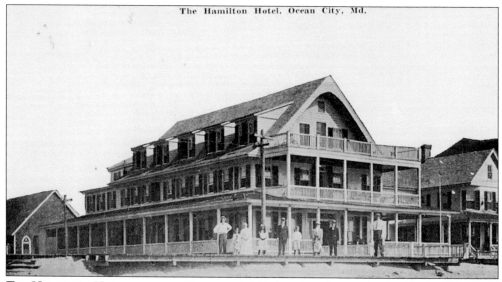

THE HAMILTON HOTEL AND THE MERVUE. A Miss Vandegrift started to build a hotel at Third Street, then discovered that her surveyor had made an error and her lots were on Fourth. She sold her rights to Josephine Massey, who bought the lot and the partially built hotel. Massey finished it and continued to enlarge it until she had a top-notch hotel that competed with the Atlantic and the Plimhimmon. The Hamilton provided excellent food, and an orchestra played in the music room during each meal. Mrs. Massey operated the hotel until her death in 1924, after which the hotel changed hands several times before it burned down in 1967. The Mervue can be seen on the north side of the Hamilton, and it was operated by Kate Taylor until 1931. Taylor's daughter, Imogene Pierce, remembers that the original cost of staying at the Mervue was $18 per week.

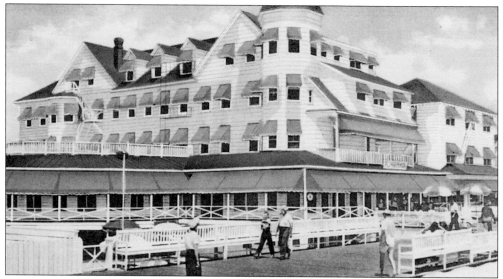

THE PLIMHIMMON, C. 1955. The Plimhimmon was operated by the Shreve family until 1941 when they sold it. Destroyed by fire in 1962, the hotel was rebuilt by its owner, who eventually sold it in 1969 to the Harrison Group, the present owner/operator. The peak of the hotel tower was saved from the fire, and, when the hotel was rebuilt, the tower was replaced on the top and links its pinnacle to the present hotel known as the Plim Plaza at Second Street.

60

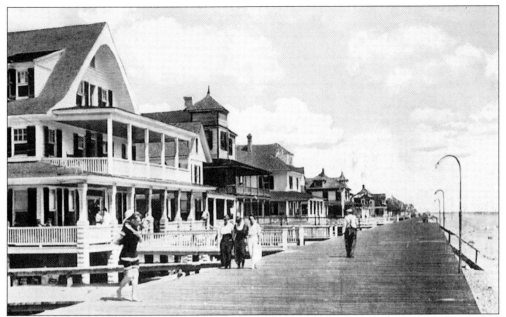

COTTAGES ON UPPER END OF BOARDWALK. When this picture was made, the boardwalk only went to Eighth Street, so this area could be called "Upper End." The Hamilton is at left, and the Mervue is next to it.

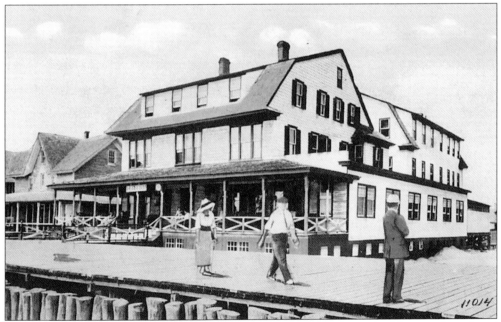

THE COLONIAL HOTEL. This 1922 picture shows the hotel after it had been enlarged and remodeled by Nellie Carter, the owner at that time. The hotel was built prior to 1907 and burned down in 1977.

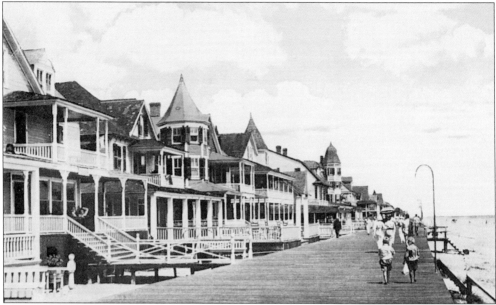

COTTAGE AND BOARDWALK FROM THE VIRGINIA COTTAGE. This view is of the Virginia. From left to right, the Linmar Hotel is the building with the first tower, the Idlewild is the second, and the Plimhimmon the third.

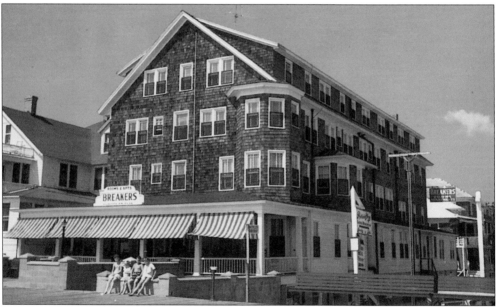

IDLEWILD—BREAKERS. The Idlewild was built by Amelia Lankford, who operated it until it was sold to Mrs. Charles H. Timmons. Timmons added a floor and stripped away the second-floor porch but left most of the tower in the corner intact. She converted it into rooms and apartments and did away with the American Plan (providing meals and lodging). The structure was located at the south corner of Third Street, across from the Hamilton. Mrs. Massey Black, whose family owned the Hamilton, says that as a child she would go to the Idlewild for hot biscuits slathered with butter. Biscuits were not served in the Hamilton, only rolls. (Courtesy of the late Fred Brueckmann.)

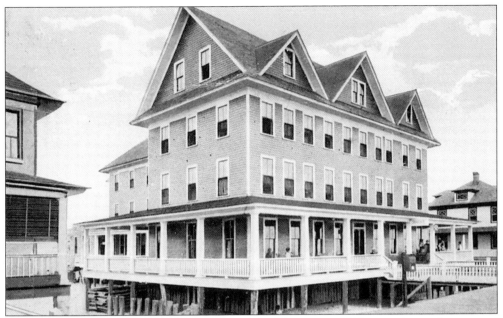

SHOREHAM HOTEL. This hotel, built by Josephine Hastings in 1922, is at the south corner of Fourth Street. Hastings sold it in 1926. It is still in operation and was always considered a fine hotel. Lois Harrison, the wife of Hale Harrison, met her husband when she was sent to Ocean City to manage the Shoreham by a hotel chain.

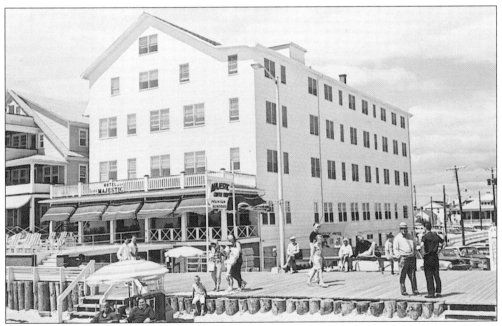

THE MAJESTIC HOTEL. The Majestic Hotel is located on Seventh Street. Originally called the Liberty Farms Hotel, it was renamed the Majestic when Susan Amanda Rounds bought it in 1945. Rounds operated it until her death in 1955. Hilda Savage, Rounds's daughter, recalls the hotel's wonderful sticky buns and the best oyster pie you ever ate. The American Plan continued until 1965 when it was phased out.

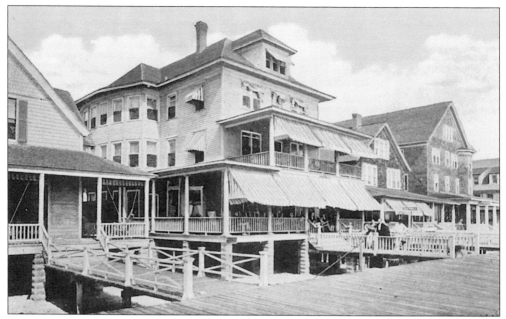

THE HASTINGS HOTEL. Josephine Hastings had learned how to build and operate hotels successfully, and although she could not read or write, she had six children who could help her. Hastings had this hotel built in 1916 on Sixth Street, and she sold it in 1922 to Willie Jones Conner, who ran it for some time. John E. Jacob ate here during this period and can testify that the cuisine was excellent. Willie turned the operation over to her daughter-in-law in 1940; she said she did not even know how to cook.

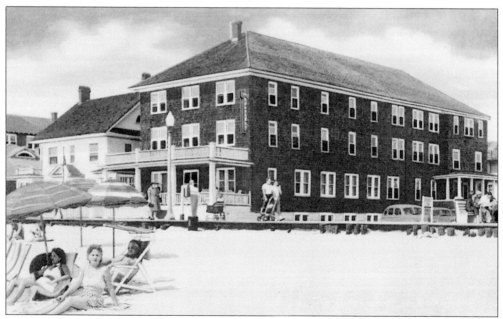

NORMANDY HOTEL. Located on Sixth Street, this hotel was operated by Mary B. Carmel. It was always operated on the European Plan (lodging only, no meals).

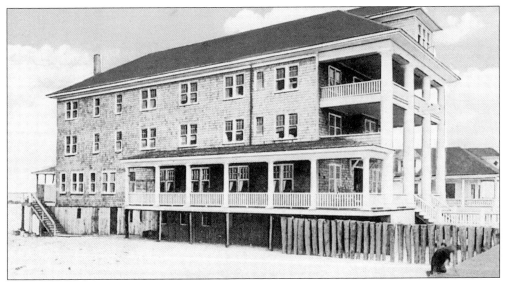

LANKFORD HOTEL. Built in 1924 by Mary Quillen and located between Eighth and Ninth Streets, this hotel presently belongs to Mr. and Mrs. J. Warren Frame. Betty Frame is Mary Quillen's niece. When Mary Quillen operated the Lankford, they had very fine food, but she finally went off the American Plan when she lost waiters and chefs to the draft in World War II and decided to lease the dining room. The lessee did not serve food of good quality, and Quillen eventually closed the kitchen. The Frames have converted the Lankford into 15 rooms and 14 apartments. This postcard is dated 1927.

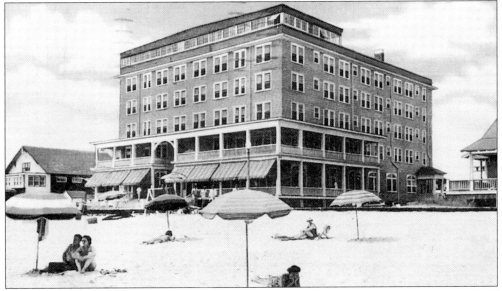

THE GEORGE WASHINGTON HOTEL. This hotel, located at Tenth Street, was the grandest of them all when it was built. A New York man purchased the land and built the hotel. Israel L. Benjamin of Salisbury took a construction mortgage on the project, and, when the owner failed to get financing, Benjamin had to foreclose. Benjamin owned the structure for about five years and then sold it. During his ownership, John E. Jacob attended the engagement party of Benjamin's daughter held in the roof garden atop the hotel. The hotel has since been torn down and replaced by condominiums. This postcard showing the building was mailed in 1952.

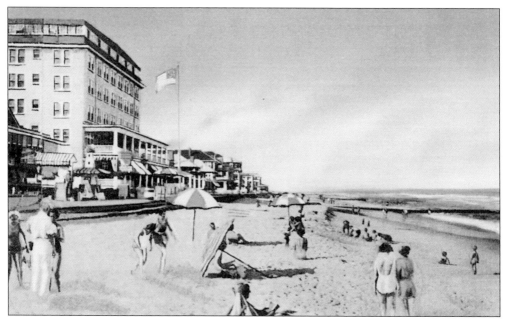

GEORGE WASHINGTON HOTEL, LOOKING NORTH. This shot, made at Tenth Street, shows Jackson's Casino on the left. The boardwalk now runs to Seventeenth Street.

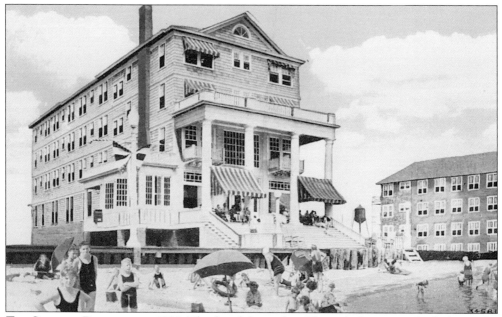

THE STEPHEN DECATUR, C. 1932. This hotel, located on Eleventh Street, was built during the Depression era by Theodore Purnell, who died a few years later. Purnell's widow, her daughter, Pauline Conley, and son-in-law, Earl Conley, operated the hotel until 1973, when it was sold to Angelo Puglisi. Puglisi ran it until 1976, when he tore it down and replaced it with condominiums.

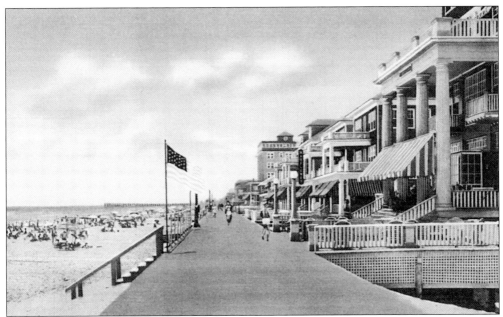

COTTAGES AND BEACH SCENE, LOOKING SOUTH FROM HOTEL STEPHEN DECATUR. You can see that the boardwalk has narrowed as it has gone north. This picture was taken at Twelfth Street; only hardy walkers went all the way to the end.

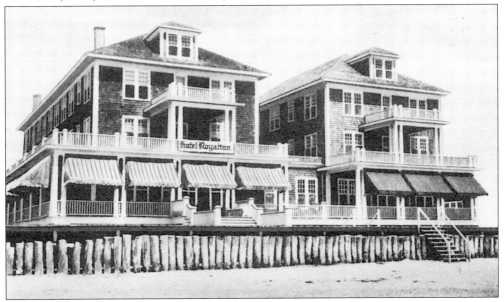

THE ROYALTON. This card shows the first two sections of the Royalton. The first was built in 1926, and the second in the 1930s. A third section was added in the 1940s and was built in partnership by Ethel Kelley and Maggie Lynch and her son. The Lynches withdrew from the partnership and were replaced by Kelley's son, the late Mayor Harry Kelley. Ethel Kelley was in her kitchen at 6:30 a.m. and stayed until the kitchen closed. She was killed in an auto accident while her son was on the city council. In her obituary was the following: "She became famous for her fine food especially her pies, cakes and rum buns." The hotel has now been sold to the Brice Phillips family.

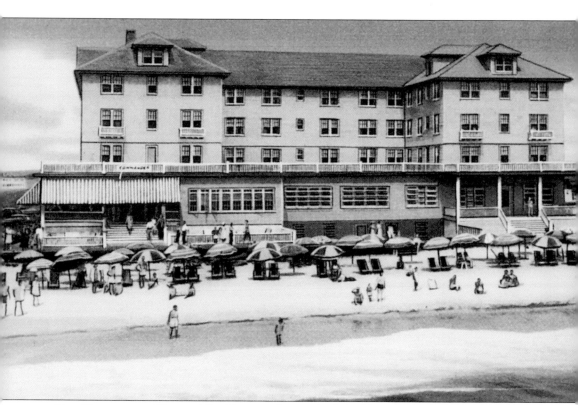

THE COMMANDER HOTEL. The Commander was built by Minnie Lynch and her son John B. in 1928 at Fourteenth Street. At first it was only one section, but later it more than doubled in size. The Commander was known for its barbecues. A huge hole would be dug in the sand, a fire built, and then all kinds of seafood, potatoes, and corn on the cob would be placed in the pit, seasoned, and covered. After the food was done, all the guests at the hotel were invited to participate. The hotel has been torn down and is currently being replaced.

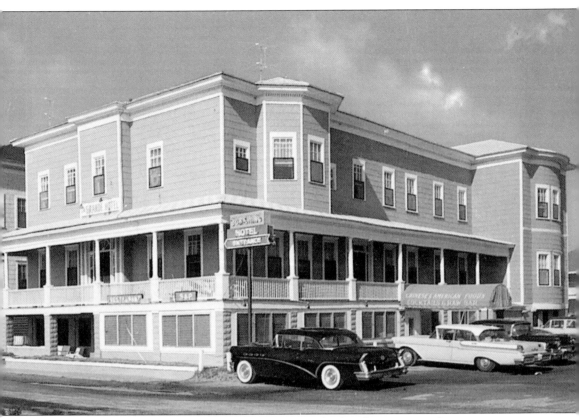

THE LA GRAND HOTEL. Located at Fourteenth Street, this hotel was separated into two parts: one half was the Dominican Fathers Retreat and the other was the Broadripple. Bob Ching came over from West Ocean City, took over the hotel, and moved his restaurant into the lower level. John E. Jacob became a year-round customer, and Ching taught him how to use chopsticks by picking up a cigarette. The hotel was damaged in the storm of 1962 and torn down. Bob Ching moved to Rehoboth. (Courtesy of the late Fred Brueckmann.)

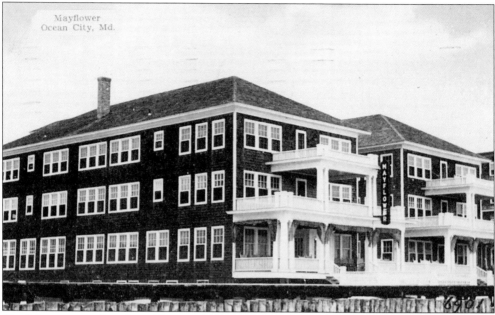

Mayflower
Ocean City, Md.

THE MAYFLOWER. Josephine Hastings built the Mayflower in 1926, a few years before her death, as her final and finest hotel. Located on Twelfth Street, it was torn down in 1988 to make way for new construction.

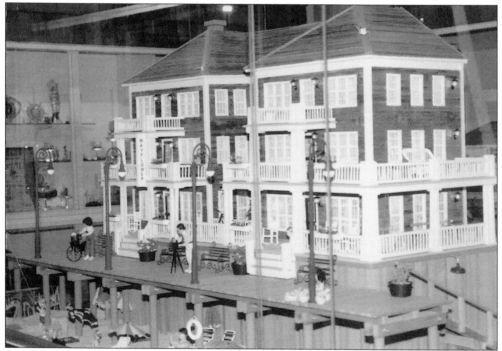

THE MAYFLOWER HOTEL. This photo of a dollhouse rendition of the hotel shows the shape and charm of the building. Each end of the hotel was L-shaped and connected by a middle section. Its large brown shingles and three stories were topped off by balconies that really added class. Rocking chairs lined the veranda. (Photo by Sandy Hurley; HPS/Pulling.)

Six

BALTIMORE AVENUE
AND THE WAY NORTH

Baltimore Avenue was the heart of Ocean City until the end of WW II. On this avenue, people attended church, and bought food at the local grocery store and stamps at the post office. The ice house, electric company, and bank had offices here. Not more than ten steps away lived 90% of the year-round residents. Philadelphia Avenue was originally a secondary street; then the railroad passenger station was moved there. When the beach highway running north to Delaware connected to it, Philadelphia Avenue's importance was increased. When Baltimore and Philadelphia became one-way streets and Philadelphia widened, Philadelphia Avenue's prominence was assured. The state roads commission sealed the matter by building a highway north between both streets. In a land title case involving land on the west side of the new road, the plaintiff's lawyer attempted to apply the law of Riparian Rights, claiming title to the few feet between his client's property and the state right-of-way. He lost.

 Although Ocean City began with only a few plots of land and the concentrated areas of Baltimore and Philadelphia Avenues, it has since grown steadily over its 125 years, spreading up to Delaware through the annexation of land. In 1961, Bobby Baker bought two blocks of oceanfront land at 118th Street and Ocean Highway, which was far away from the rest of the resort. This was the first time anyone had extended the seaside retreat that far north. Over time, annexations allowed the resort to impose itself farther north until the late 1960s, when Ocean City halted any further land acquisitions and instead adjusted to what it had. However, as the city began moving north, its profile changed. Instead of a boardwalk lined with shops and booths, only sand existed and a beach line that faced erosion.

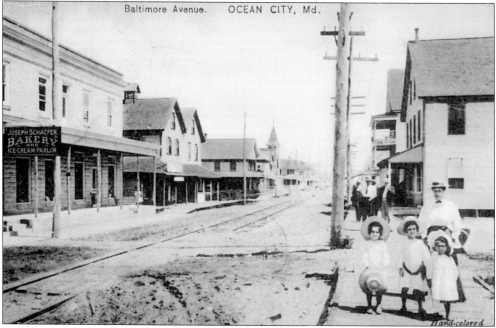

BALTIMORE AVENUE. This card is the first to show Baltimore Avenue as it used to be. The railroad tracks ran down it and you would have to wear high-tops to keep the sand out of your shoes. The sign on the left says "Joseph Shaefer's Bakery and Ice Cream Parlor." Frances Massey Black, at 93 years of age, still rhapsodizes over the cookies that were baked there. The three princesses at right are dressed in costumes of the day and their mother's skirt is still at ground level. The time is c. 1908. (Courtesy of David Dypsky.)

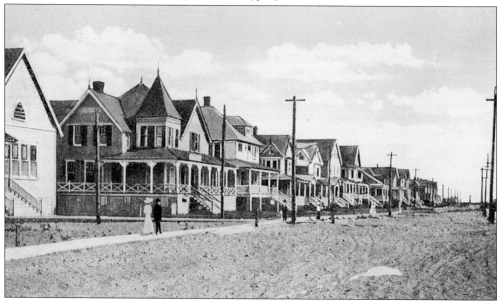

BALTIMORE AVENUE. The Presbyterian church at left tells us that this is North Division Street. The house next to it was called the Gables and was built prior to 1897. The rest of the houses were built after the turn of the century. The woman walking along would have to hold up her skirt in order to cross the street. This image is postmarked 1912.

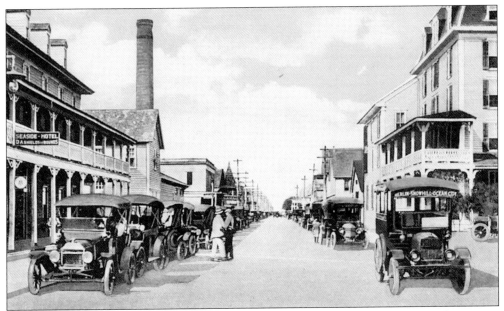

BALTIMORE AVENUE, SHOWING AUTO LINE. Baltimore Avenue has been paved! This picture also shows Seaside Hotel on the left and the Atlantic Hotel on the right. The railroad tracks have been moved to Philadelphia Avenue. The steam-powered laundry is north of the Seaside, with the Electric Company north of the laundry. Notice the two buses parked on the east side of the street. Their logo reads "Berlin, Snow Hill and Ocean City."

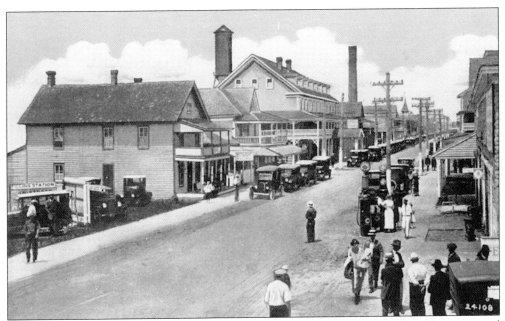

BALTIMORE AVENUE. The Seaside is still in the picture. South of it is Coffin's Pharmacy and Bazaar, and south of that is the old post office, now a restaurant. The real points of interest, however, are the filling station on the west side of the street and the gasoline pump on the east side, in the street bed. A woman with her back to the camera is pumping gas. (Courtesy of David Dypsky.)

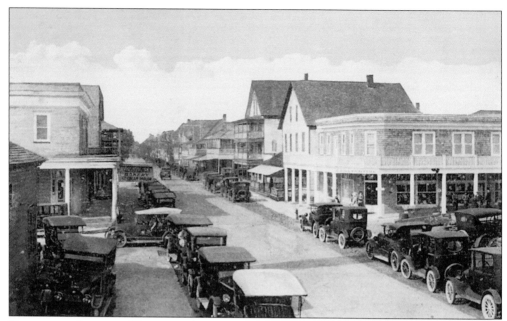

BALTIMORE AVENUE. We are in the same neighborhood and the scene is the same as the one depicted in the first shot in this chapter. The bakery is still at left, but at the right is Constantine's, a new variety store. It was run by a "furriner" in Ocean City.

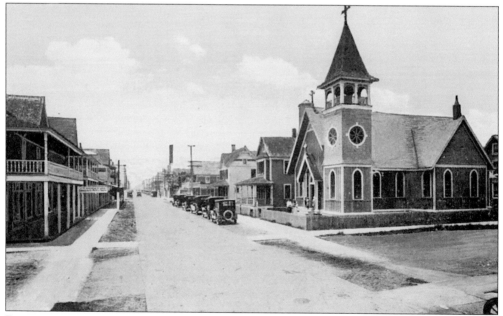

BALTIMORE AVENUE BOULEVARD. This picture shows the original pavement of Baltimore Avenue. Consisting of only a strip down the center, the pavement did not cover the parking areas, but concrete extensions were built to connect the paved street to the sidewalk. The new Catholic church and rectory are visible. (Courtesy of David Dypsky.)

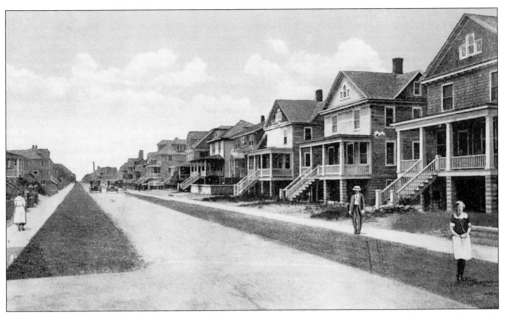

BALTIMORE AVENUE, LOOKING SOUTH. The parking areas are not grass; they are still sand. The street bed could still be used by children for roller skating, but when a car was coming and a child had to resort to the sidewalk, he reached it in two jumps: the first in the sand and the second to the sidewalk, where he had to stamp his feet to rid the wheels of sand. For this reason, children in Ocean City learned not to oil their skates.

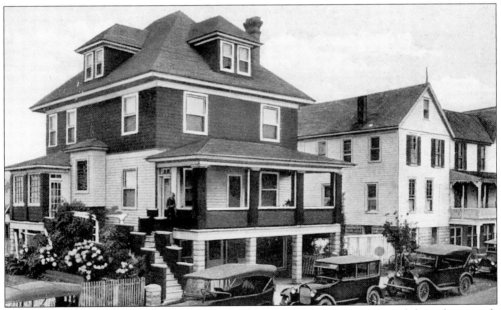

DR. TOWNSEND'S COTTAGE. The fact that his house is featured on a postcard shows how much affection and respect was given to old Dr. Frank Townsend. His office was in the basement and his living quarters were above it. This is also a testimony to the low cost of medical services in the 1920s. (Courtesy of David Dypsky.)

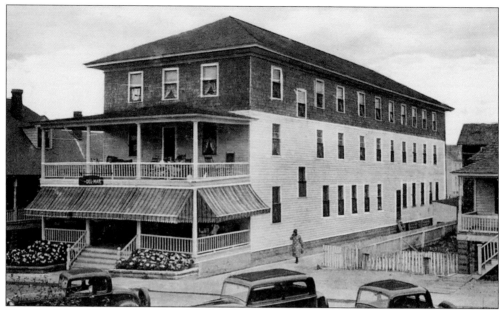

THE DELMAR HOTEL. This hotel, located on North Division Street, was first operated by Savannah Carey and later by her niece, M. Elizabeth Powell.

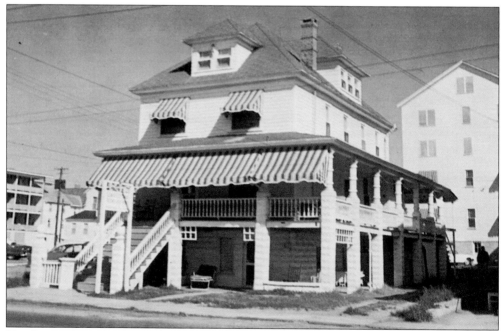

THE LEWIS COTTAGE. Still there and still operating under the same name, the Lewis Cottage stands alone. To the left is the parking lot for the Rideau Motor Inn. The building behind it is now part of the rebuilt Rideau. (Courtesy of the late Fred Brueckmann.)

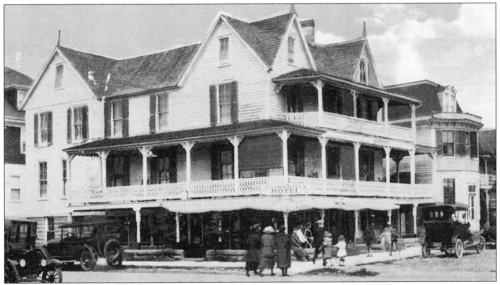

The New Avelon Hotel, Ocean City, Md.

THE NEW AVELON HOTEL. Located between North Division and First Street, the New Avelon Hotel was the first hotel operated by Josephine Richardson Hastings. She never paid for any work she could do herself. Hastings was a big woman, comfortably padded, and one day while she was bent over washing windows, a neighboring boy with a BB gun spotted this target of opportunity, took aim, and fired. Then, realizing if caught he would get a whipping, he disappeared behind some friendly pilings. Mrs. Hastings's reaction was never recorded. Shortly thereafter, in 1916, she sold the hotel.

THE AVONDALE HOTEL. This hotel, located on the northwest corner of Talbot and Baltimore, was operated by the Grimm family. Their youngest child fell from a second-story window in the hotel and was killed. The grief-stricken family immediately put the hotel up for sale. Mr. and Mrs. George Rounds bought it and operated it until 1926, when they bought the New Avelon, which they renamed the Delmarva. The name has now been changed back to the Avelon Hotel. (Courtesy of David Dypsky.)

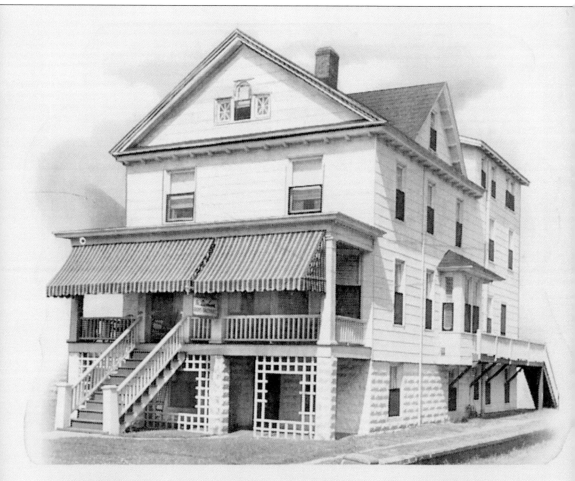

THE DUNLEER, 209 NORTH BALTIMORE AVENUE OCEAN CITY, MARYLAND

THE DUNLEER. This building is no longer standing. It was like so many buildings built in Ocean City, consisting of a block first floor (built on a concrete slab as protection against floods) and a second floor with a porch and an extension on the back, with a separate stairway to it. (Courtesy of the late Fred Brueckmann.)

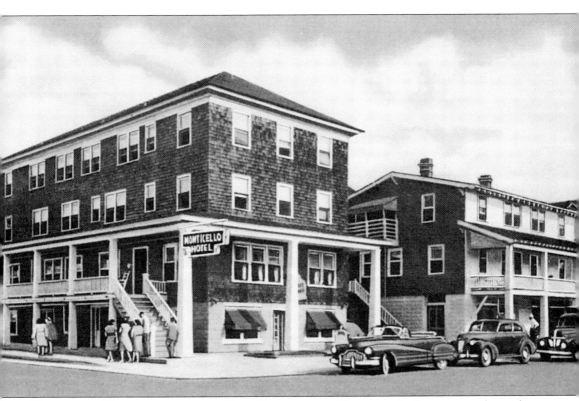

Monticello Hotel and Dinner Bell Restaurant. These two businesses were located on the southeast corner of Third Street and Baltimore Avenue. The Dinner Bell Restaurant occupied the whole basement, except for a small office in the front corner, which was the local office of the Sunshine Laundry. The restaurant was a popular eating place in the 1930s and 1940s. One could get a steak dinner there for a dollar, and it didn't matter that the steak was only a quarter of an inch thick. The lobby of the Monticello Hotel was inside the door at the top of the stairs. The basement is now occupied by Don's Bike and Beach rentals. The hotel has lost its sign but is still open. (Courtesy of David Dypsky.)

THE BELMONT HOTEL AND COTTAGES. The Belmont-Hearne Hotel was built by Elizabeth Harper Hearne after her husband died in 1902. Lizzie bought a cottage and renamed it the Belmont and began taking in guests. In 1910, she built a house next to the first one and called it the Hearne. She left this building to her daughter Minnie Jones in 1936, who in turn left it to her granddaughter Kate Bunting. The buildings face Dorchester Avenue and are behind the Hotel Nordica.

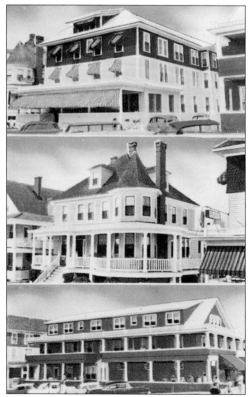

THE BELMONT, BELMONT COTTAGE, AND THE HEARNE. This is how the property looked in the mid-1940s, when Minnie still owned the property. It is shabbier today. (Courtesy of the late Fred Brueckmann.)

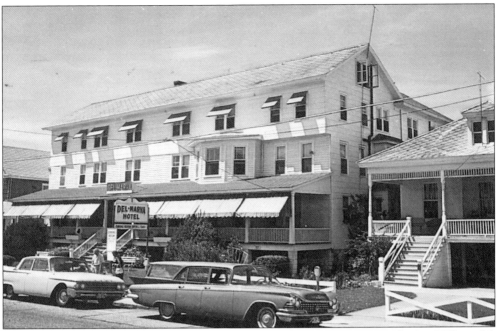

THE HOTEL DELMARVA. Susie Rounds sold this hotel in 1945 to Mr. and Mrs. William M. Currier. The hotel boasts the oldest continuous operating dining room in any hotel, having fed guests since 1902. The hotel's name has now been changed back to the Avelon Hotel. It's been rebuilt and so changed that the only remaining element from this view is the bay window on the second floor of the north building. This image is dated c. 1950.

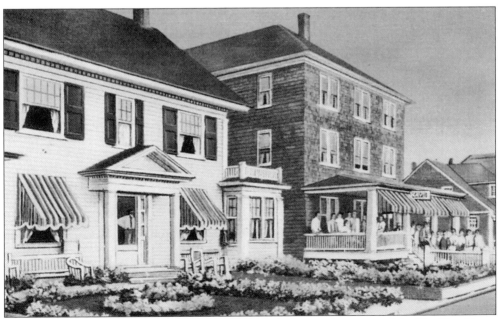

COTTAGES AND KAY HOTEL. At the corner of Ninth Street, the guests of the Kay Hotel have been rounded up for this picture. The hotel was built in the 1930s and was part of the brown-shingle era.

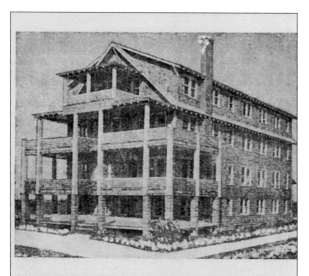

HARRISON APARTMENTS. When the Harrison was built in 1926, only the Jesuit summer home was farther north. The Harrison was managed by Della K. Powell until her death, when it was passed on to a nephew; it is still family-owned. Mrs. Powell was a Harrison.

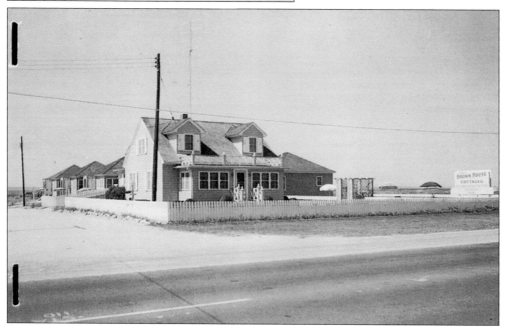

THE BROWN HOUSE COTTAGES. Located on Ocean Highway, the Brown House Cottages are known for their spotless exterior and interior and are a landmark in their own right. They are easily seen from the Coastal Highway on the way north to Delaware. (Courtesy of the late Fred Brueckmann.)

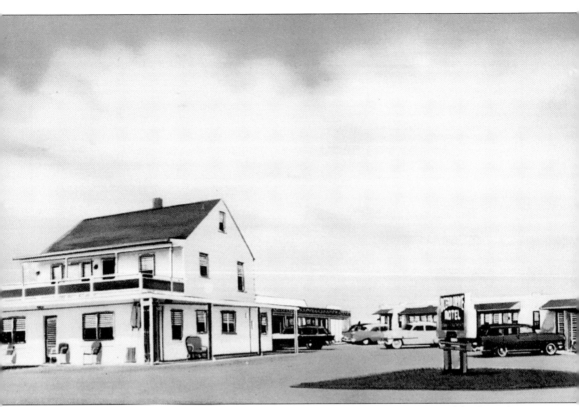

OCEAN DRIVE MOTEL. Owned and operated years ago by Mrs. Gustav Strohhacker, this lodging facility was located on what was then called Beach Highway and Sixty-Ninth Street in North Ocean City. The facility, positioned between the ocean and the bay, offered surf fishing, a playground, a picnic area, and a pier for boating and crabbing. (Courtesy of David Dypsky.)

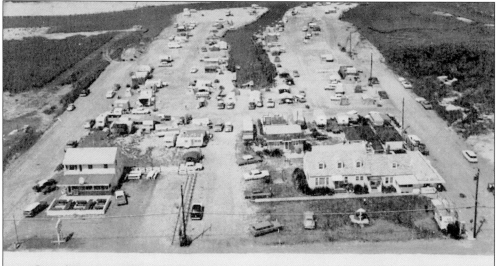

The Wishing Well Camp 70TH ST. & BEACH HIGHWAY OCEAN CITY, MARYLAND

WISHING WELL CAMP. With "Lovely furnished apartments overlooking the Sinepuxent Bay—one block from the ocean," the Wishing Well was a popular lodging spot. These two postcards are akin to before-and-after photos. Here, the store and office are at lower right, the two streets on each side have been filled in, and, in the center, the stream is shown as a dark mass. Marshlands exist behind the filled land. The camp was built on the leveled area. (Courtesy of David Dypsky.)

Greetings from OCEAN CITY Maryland

WISHING WELL. Here, the land has been filled and bulkheaded, and a canal has been created between the property and bay. The former gut is now a dredged channel in the center of the property. All this happened before the draining and filling of marshlands became illegal and the protection of marshlands was rigorously enforced. But, as is true with most Ocean City properties, the land is worth several times more than what it originally cost. (Courtesy of David Dypsky.)

Seven

CHURCHES OF THE TIME

By the end of the 1800s, Ocean City was becoming a microcosm of the outside world. While cottages, boarding houses, and hotels were taking root, churches, too, were sprouting up on the strip. The people of the time worked hard for their faith and for their churches, of which there were four denominations until 1947: Catholic, Episcopal, Presbyterian, and Methodist. Baptists came later.

St. Mary's Star of the Sea Catholic Church, constructed around 1878, was the first church built. St. Mary's was established by Wilmington Diocesan Bishop Becker who vacationed at the ocean during the summer and used the church as a retreat center. Until 1931, the church operated only during the summer.

The first Episcopal church, St. Paul's by the Sea, appeared by 1881. The original property housing the church was near the inlet and is believed to have been a cottage that now quarters the renown Adolfo's Restaurant. This gothic, turn-of-the-century church was rebuilt in 1899 at 302 N. Baltimore Avenue on subsidized land, where it remains today. St. Paul's by the Sea was built on two lots donated by John Waggeman in 1898 as a mission church and was dedicated in 1903.

Founded in the late 1800s, the Ocean City Baptist Chapel was originally a Presbyterian church until the Baptists purchased it. Located at 102 North Division Street, this denomination is active in the town, performing concerts on the boardwalk and hosting events for both adults and youth.

An old saloon was used for Sunday school services for Presbyterians in 1890. When philanthropist Alice Waggeman provided a lot on the corner of Baltimore Avenue and North Division Street, the congregation raised funds to establish a building. Today, descendants of original island investors still attend the First Presbyterian Church, which has since relocated to Thirteenth Street and Philadelphia. The inside of the church is shaped like an inverted boat.

According to an 1897 insurance atlas, a Methodist church existed on Dorchester Street, but a lack of funding meant that parishioners of the Atlantic Methodist Church had to meet in several places until they were able to erect their own building in 1919, on Fourth Street and Baltimore Avenue.

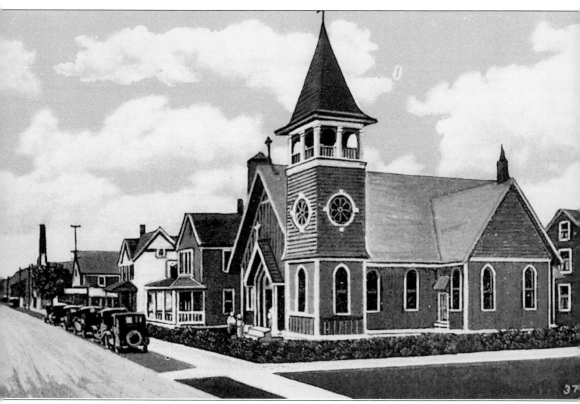

St. Mary's Star of the Sea Catholic Church. This was the first church in Ocean City and was built by Bishop Becker with the initial intent to use it for spiritual retreats. The bishop purchased three lots for $300 on Baltimore Avenue. In 1910, it became a mission church of St. Francis de Sales Church in Salisbury, only to undergo expansions and renovations in 1939, doubling its seating capacity. This single-story church with its three-story bell tower is still in existence at 208 South Baltimore. A twentieth-century-style rectory was constructed on the south side of the church. This photo was taken around 1912. (Courtesy of M.)

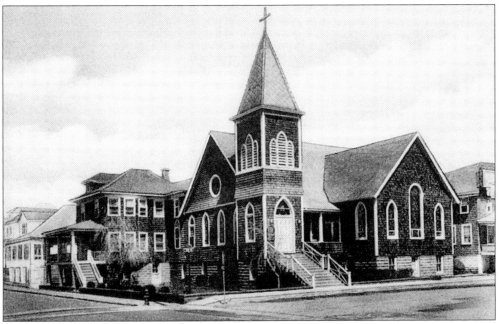

ST. PAUL'S BY THE SEA EPISCOPAL CHURCH. Because of the large numbers of Episcopalians settling and vacationing in Ocean City, there was a demand for a formal church. Founded in 1881, this church was originally located near Congress Hall Hotel, by the inlet in what is now Adolfo's Restaurant. It was rebuilt in 1898–1899 at 302 Baltimore Avenue, where it remains today. Christopher Ludlam purchased the old church, and the congregation used the proceeds from the sale to help build their new church. The move was due to the generosity of John and Alice Waggeman, who donated two lots at the Baltimore Avenue location. St. Paul's was the first church to hold year-round services. (Brotherhood of St. Andrew.)

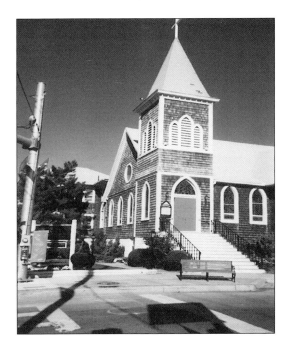

ST. PAUL'S BY THE SEA EPISCOPAL CHURCH. This 1998 view shows the church in a more modern perspective. Today, the congregation includes about 300 families. A variety of services are offered, including Bible study, choir, youth activities, a golf tournament, and an antique show that has been held 54 times. (Courtesy of K. Bringham and C. Hussey.)

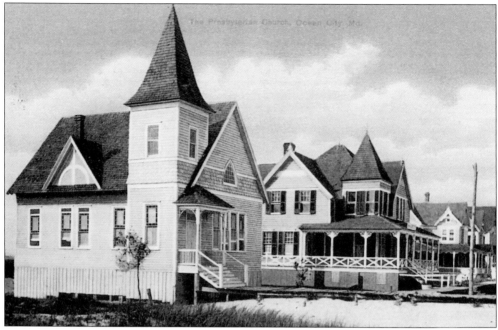

The Presbyterian Church. The Presbyterian church originated around 1890 through the efforts of Ella Dennis, who held Sunday school lessons in a saloon. Begun as a mission church in 1892, it wasn't until 1896 that a sanctuary was built for $1,000 at Baltimore Avenue and North Division Street. In 1909, the mission church was chartered as a congregation. Then, in 1963, a contemporary brick church was erected at the corner of Thirteenth Street and Philadelphia Avenue, where it remains today. (Courtesy of Tingle.)

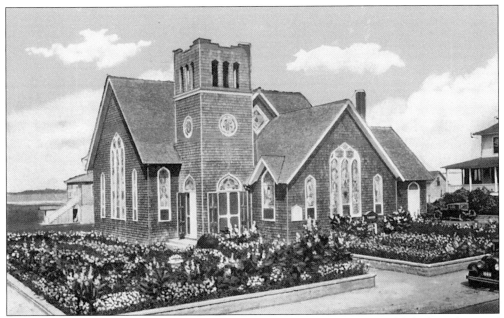

ATLANTIC METHODIST EPISCOPAL CHURCH. Although not officially established until around 1919, the Methodist church was recognized and on the maps as early as 1897. They had held services at various places until a permanent structure on Dorchester Street was constructed. Today, at Fourth Street and Baltimore Avenue, the congregation has grown to 815 members. (Courtesy of David Dypsky.)

ATLANTIC METHODIST CHURCH. The church in the previous image was later replaced by this large brick church, where a growing population of parishioners attend. (Courtesy of the late Fred Brueckmann.)

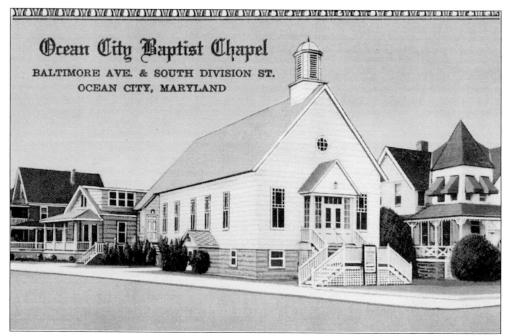

OCEAN CITY BAPTIST CHAPEL. Founded in the late 1800s, the Baptists met in numerous coffee houses until the congregation purchased the building that housed the original Presbyterian church. The single-story frame building sits on a concrete foundation and has undergone renovations.

OCEAN CITY BAPTIST CHURCH. Still located at the corner of Baltimore Avenue and South Division Street, the Baptist Chapel has been here for over 35 years. Over time, the building has been sided and additions have been put on that have changed the overall appearance of the building. Currently, the 200 members provide numerous activities such as winter retreats and summer concerts on the boardwalk. (Courtesy of K. Bringham and C. Hussey.)

Eight

EDUCATION

Education in Ocean City does not have an extensive history, but the island's past is replete with attempts at education. The year 1901 boasted the town's first school, which was probably farmhouse in style, at the corner of North Division Street and Philadelphia Avenue; it housed grades one through six. The Presbyterian church offered classroom space to kindergartners in 1914. Since there were no facilities of convenience, surrounding residents supplied water to the children. At one point, what is now the Bamboo Apartments on Third Street and Philadelphia Avenue served as the only public school on the island.

The State Department of Education built in 1915 what is today's city hall on Third Street and Baltimore Avenue with the exclusive intent of preparing high school graduates for teaching positions. The building was sold by the state in 1917 to Worcester County to become the first elementary/high school in Ocean City. During the 1920s, Ocean City had to enlarge its only high school, while the elementary grades held their own. Credit goes to the many women in the town who fed those hungry students whose parents couldn't afford food for them. By the 1950s, the only high school on the strip was moved to the mainland in Berlin, Maryland, and is now the Stephen Decatur High School. A decade later, all island children were attending mainland schools that were larger and offered greater conveniences. It is at this time, around 1968, that the Worcester County school system sold the old high school to the city of Ocean City, which used it as a city hall after renovations. At the threshold of the new millennium, Ocean City still has no public schools, and the only form of higher education is found in the elderhostel programs sponsored by the University of Maryland Eastern Shore.

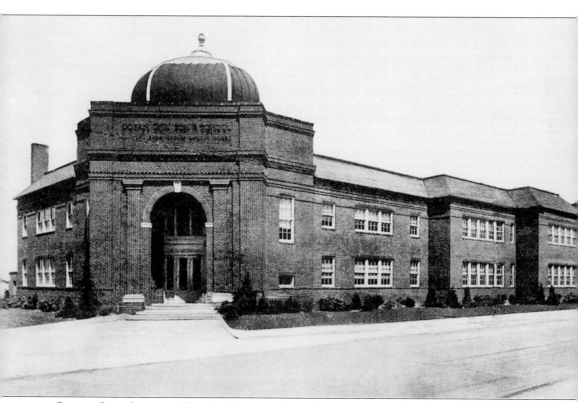

OCEAN CITY SCHOOL. This building served as the town's high school. It originated in 1915 as a teachers' training facility during the school term and was used as the headquarters for the Maryland State Department in the summers. In 1917, the state sold the building to Worcester County to open as the resort's school. In 1931, ten students graduated from the high school. Fifty years later, Worcester County sold the domed building to Ocean City for $90,000. Notice the two extra additions that were made after the county acquired it. (Courtesy of David Dypsky.)

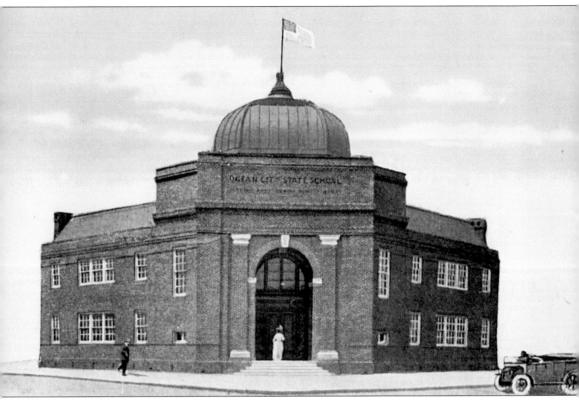

OCEAN CITY STATE SCHOOL. Located on the corner of Baltimore Avenue and Third Street, this teachers' college, or "normal" school, trained young adults to be teachers under the auspices of the Maryland State Department of Education. The only other existing teachers' college was in Towson, Maryland—a considerable distance to travel. During this time, females were discouraged from becoming teachers, and it wasn't until 1932 that married women were permitted to obtain their teaching certification. Teachers were expected to have a highly moral life, and smoking, drinking, as well as visiting "questionable" places of lowly behavior, were forbidden. (Courtesy of David Dypsky.)

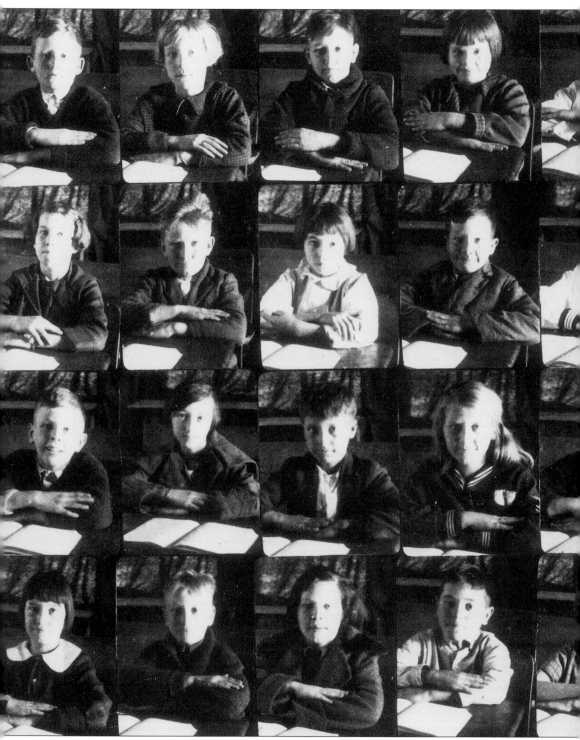

SCHOOL PHOTO. This school picture was taken sometime in the 1920s. Each student is clean-cut looking, with arms folded atop desks and a book open. Notice the dress and haircut styles

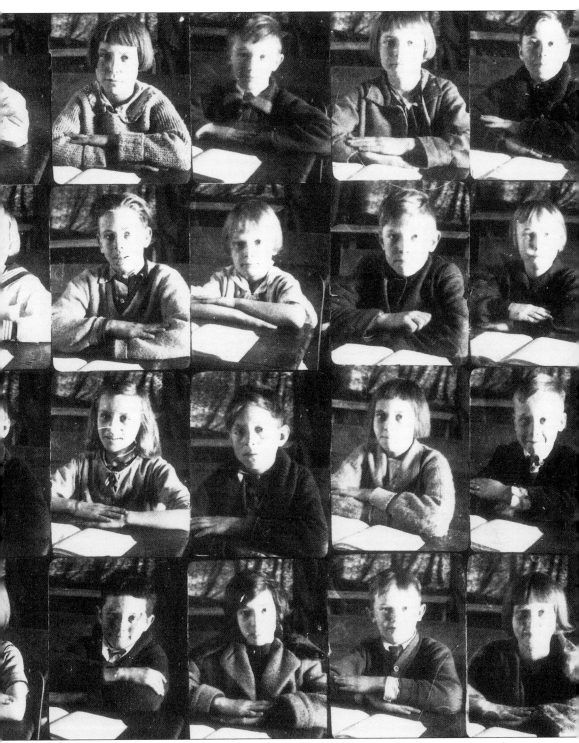

of the time. Today, many of these former students have served their communities as leaders, professionals, and in the business and service industries. (Courtesy of Dr. F. Townsend.)

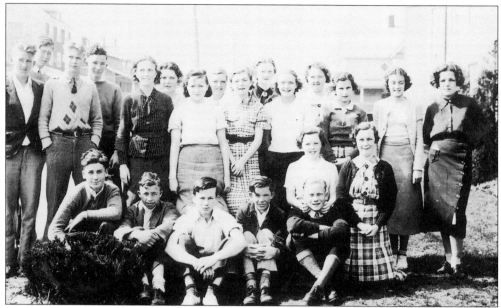

EDUCATION, C. 1935. These two photos feature students and faculty of Ocean City High School during the mid-1930s. Dr. Townsend and Quigley Bennett identify some of the models in the two photos as James Parker, Betsy Jane Dennis, George Gibbs, Esther Simpson, the "Cropper kids," Margaret Burbage, Myra Powell, and William Lewis Bennett, the principal. Notice the style of dress in the school picture. The female students are wearing skirts and dresses, and the young men are sporting short hair cuts, sweaters, and even ties. It is an interesting contrast to the attire worn by today's students. (Courtesy of W. Quigley Bennett.)

Nine

ENTERTAINMENT

From Ocean City's inception, smart business people provided fun beyond sunbathing and eating. Dan Trimper came along with an amusement park, with tons of food and various concession stands. In no time, he turned the south end of the boardwalk into fun city. A Trimper merry-go-round has been in operation since 1912, and, today, its animals are considered "classics." The Atlantic Hotel was one of the first to offer such indoor recreational activities as billiards, dancing, card games, arts and crafts, games of chance, and other projects. Skating rinks, American and Japanese bowling, golf courses—both miniature and par three—and sailing or sport fishing soon abounded. Duck and trapshooting and live mouse races also offered diversion, along with pony rides on the beach, theater-going, tea rooms, and fortune telling visits. The boardwalk featured beauty contests, a funhouse with "Laughing Sal," and numerous shops and booths offered souvenirs, candy, popcorn, taffy, hot dogs, and other foods. The Easter celebration and parade emerged in the early 1940s and so did baseball. The Dominican Brothers team used uniforms handed down by the Washington Senators. Along with cheering at the games came hot-footing on the ballroom floor. Frank Sacca entertained on the boardwalk in the 1920s, and, later, the big bands of Jimmy Dorsey, Harry James, Benny Goodman, Guy Lombardo, and Glen Miller also played. Dressed in their finery, couples walked the boardwalk, arm in arm, heading for the music. Back then, it was customary for everyone to dress up and promenade on the "boards." The Atlantic and Plim Hotels became famous for their dancing and buffets, along with other eateries such as the Ship's Cafe Restaurant and Marina and Rick's Raft Club.

Unfortunately, gambling arrived, starting with penny slot machines and expanding until nearly every hotel offered some form of betting. In no time, fathers started losing and cutting short their family vacations because of losses at crap games or slot machines; some had to beg their landladies for a partial refund in order to return home. Then along came Worcester County's state attorney, Jack Sanford, who crushed gambling in Ocean City and returned entertainment to riding merry-go-rounds and jamming bumper cars. Mom and Pop no longer had a place to lose their nickels, and soon Ocean City regained its status as a family vacation spot.

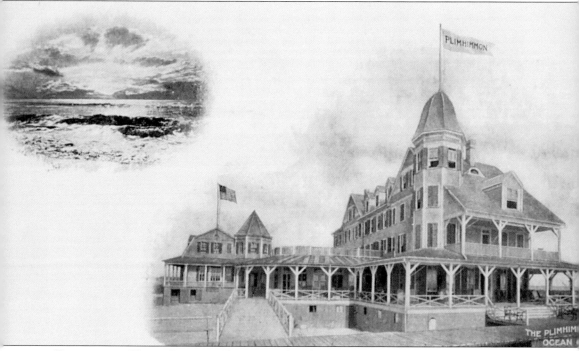

PLIMHIMMON HOTEL DANCING PAVILION. This shot gives insight into this Victorian hotel's size and style. Built in 1893 by Rosalie Tilghman Shreve (speculated at about $9,000), the original section was no more than a three-story building that grew over time. Rosalie, widowed at age 20, confirmed that the hotel offered excellent service and incredibly fine food, with a huge midday meal during which an orchestra played—a central feature of the hotel's service. After lunch, resort visitors would nap in their rooms or on porch rockers, staying out of the afternoon sun, and later, they would dress in their Sunday best for the evening meal and a promenade on the crowded "boards." The hotel boasted a dancing pavilion surrounded by an open porch with glass doors and large windows opening to the dance floor. In the center was a six-sided gabled window used to vent excess heat. It is believed that this form of entertainment continued until the 1925 fire.

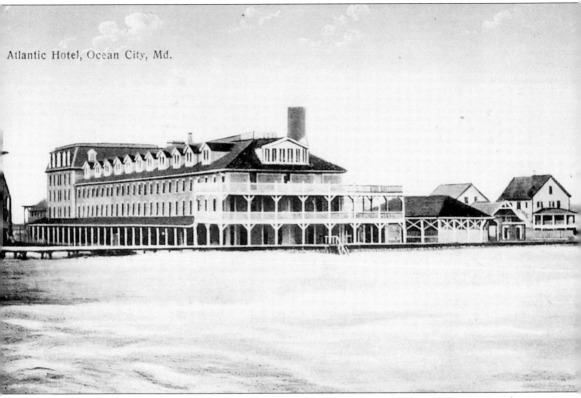

Atlantic Hotel, Ocean City, Md.

ATLANTIC HOTEL DANCING PAVILION. This c. 1911 photo depicts a large, Victorian-style, 210-room lodging facility that should have opened in 1874 but first had to be rebuilt after March high winds caused it to collapse; it opened on July 4, 1875. At the hotel, lavish rooms, extraordinary service and entertainment, and unique amenities (wash stands, wash bowls, water pitchers, soft goose-down mattresses, and polished oil lamps) brought in a daily $2.50 fee, with weekly package rates set at $12.50–$15. After the railroad was built, revenues picked up but never enough to greatly profit the Atlantic Hotel Company Corporation, which was comprised of Col. Lemuel Showell, D. Jones Taylor, R. Jenkins Henry, George W. Purnell, and Purnell Toadvine. In 1925, the hotel burned and again had to be rebuilt. The famous dancing pavilion, which was separate from the hotel, had a roof with a protective overhang and wide-open walls to welcome the ocean breeze. The pavilion wasn't so much for dating duos as it was for older, married couples who waltzed and fox-trotted off dinner until the band played "Good Night, Ladies."

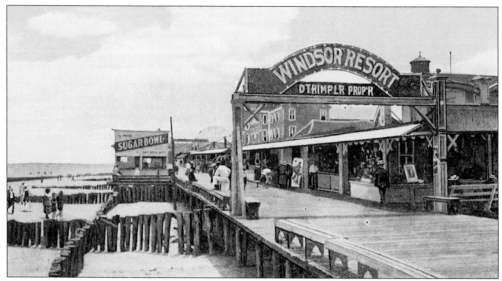

WINDSOR RESORT ON THE BOARDWALK. Founded by the Trimper family, Windsor Resort became known as Luna Park, and, later, as Trimper Amusements. Dan Trimper and his brother named the business Windsor Resort to reflect the inclusion of both the Windsor Hotel and the Eastern Shore hotel. It featured its own boardwalk and an arched wooden frame with Trimper's name on it. The storm of 1933 destroyed much of the boardwalk and several rides and amusements in Luna Park. (Courtesy of David Dypsky.)

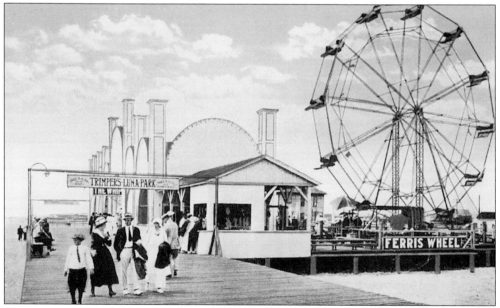

TRIMPER'S FAMOUS AMUSEMENTS. Located on the south end of the boardwalk near the inlet, Trimper's rides have been in existence for nearly a century, attracting both the young and old. Filled with specialty shops, food counters, and game stands, this end of the boardwalk also features the Lifesaving Museum and Harrison's Restaurant. The inlet itself serves as a major attraction, with its jostling waves and colorful history detailing the 1933 storm. Over the years, the Trimper family has added various rides and other amusements. (Courtesy of the late Fred Brueckmann.)

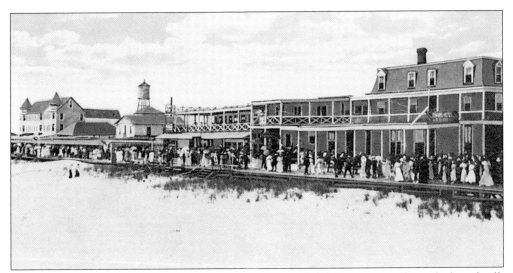

AMUSEMENT SECTION OF BOARDWALK. Men, women, and children promenade on the boardwalk in their finest clothes, representing the genteel class of society. This informal promenade on the boards was as much a part of daily resort living as eating and playing. After a large meal, and when the sun wasn't at its peak, guests would parade from one end of the boardwalk to the other, meeting and greeting others as if at a ball. The very well-to-do could afford to pay others to roll them up and down the boardwalk in wheeled chairs. After the storm of 1933 cut an inlet through the land, walking to the far south end of the boards was a main event of the day. The buildings with the upstairs porches are now part of Trimper's domain. The length of the women's dresses points to an early date.

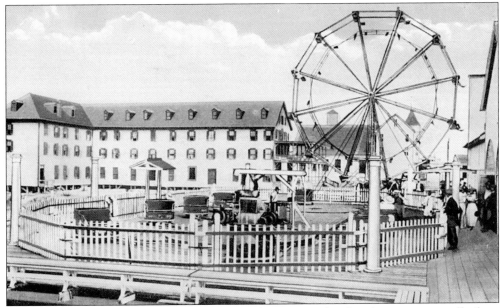

THE WHIP AND FERRIS WHEEL. Owned by the Trimper family, who were originally from Baltimore, the park is still in existence today. Daniel B. Trimper ran the Whip through generators since there was no electricity. The ride is housed in a building in Luna Park that was destroyed in the 1933 storm. The park originated with the Trimpers and has remained in the family—now the fourth generation—for over 100 years.

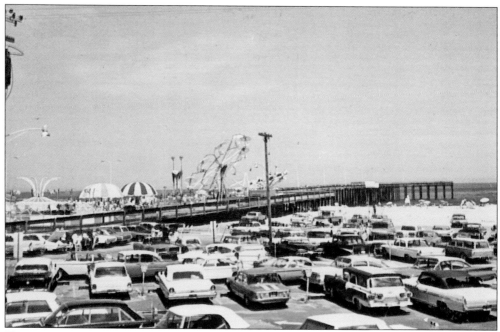

TRIMPER'S AMUSEMENTS. This picture is included to show that the Trimpers have moved most of their rides across the boardwalk to the beach to take advantage of the widened sand. It also shows the parking area, which was a result of the deal between the Trimpers and the City.

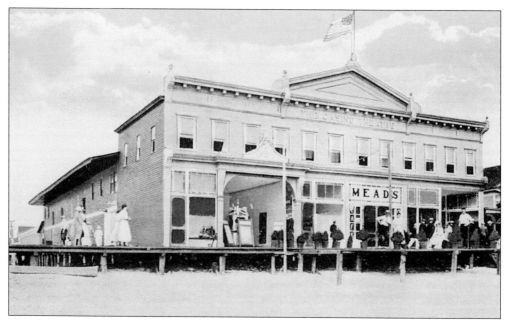

THE CASINO THEATER. Located on the boardwalk, across from the pier, Mead's Cafe became famous for the popcorn it provided. Notice the style of the building and how well-dressed the tourists are. The movies were a popular amusement in the silent days, and, judging by the style of dress, this photo is likely dated around the late 1920s.

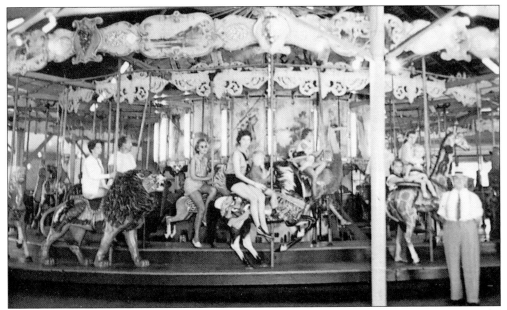

BEAUTIFUL MERRY-GO-ROUND. Around 1902, Herschel Spillman of North Tonawanda, New York, sold this state-of-the-art carousel to Dan Trimper in Ocean City. It measured 50 feet in diameter and carried 45 finely carved animals. In the carousel's early days, each ride cost a nickel. The carousel was driven by steam before it was operated by electricity, which it shared with another ride. This merry-go-round is the oldest, continuously operating carousel in America, and its fine, museum-preserved animal rides by the Trimper family allow it to remain operable even today. (Courtesy of the late Fred Brueckmann.)

HAND-CARVED ROSE HORSE. This horse is one of the 52 animals featured on the restored 1902 Herschel Spillman carousel. Other featured animals are lions, tiger, frogs, ostriches, and even a dragon, all of which were hand-carved by German crafters. The delicately honed details of each animal continue to be carefully maintained. (Courtesy of HPS/Pulling.)

RAYNES, JULY 1936. Dan Trimper III and Buck Rousey eat 5¢ ice cream cones at Raynes. Here, we see a Trimper interested in something other than rides. (Courtesy of W. Quigley Bennett.)

BOWLING ALLEY. One of the major forms of entertainment, as shown in this 1930s photo, bowling ranked right up there with swimming; you can see a youth diving into the water. The sign underneath the roof eave of the bowling alley reads: "Luncheonette; beer on draught." (Courtesy of W. Quigley Bennett.)

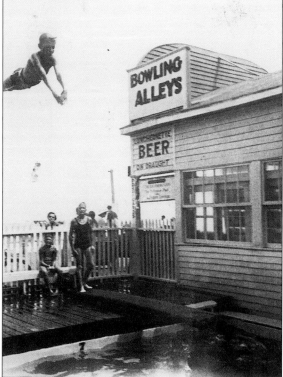

SHOWELL SWIMMING POOL. The Showell family came to Ocean City from Berlin, Maryland, in 1896 and built the Oceanic Hotel on North Division Street and Caroline Street. The swimming pool pictured here was the first in the resort. A pipe running from the ocean pumped seawater into the pool. Visitors dressed up just to stand around the pool and watch young swimmers dive into the water for coins. Bathing suits bearing an "S" on them could be rented for 25¢ and swimming in the unchlorinated pool cost an admission rate of 25¢. Showells also owned Showell's Bathhouse, the Blue Lattice (a tea room), and Showell's Theater, and referred to the clustered buildings as Showell's block. Today, the Sundancer (a surfing shop) is owned by fourth-generation Showells.

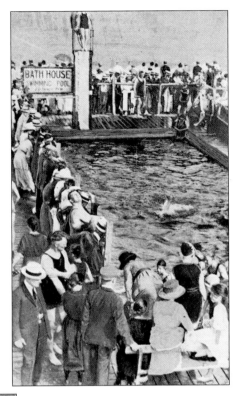

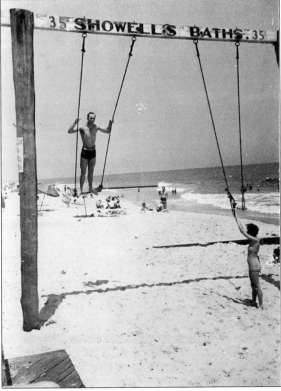

SHOWELL'S. The sign for Showell's Baths, a famous swimming facility, is highlighted here, where tourists romp on swings. This picture was taken in the mid-1930s. (Courtesy of W. Quigley Bennett.)

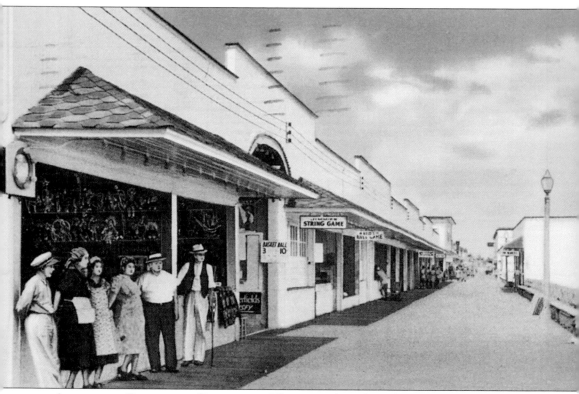

AMUSEMENT CENTER AND BOARDWALK. This image dates from the 1920s. Games offered were "Basketball: 3 balls for 10¢," the string game (where all the strings ran through a ring in the center), and the "red ball" game. The shop in the foreground has dolls for the lucky winners. Besides games, food, and specialty stores, retail shops and various types of amusements filled the boards. Trimper's amusements have become the hallmark of the inlet and boardwalk at South First Street. The long history of Trimper's amusements shows a true dedication to the city; the family had to rebuild many of their rides and diversions because of disasters.

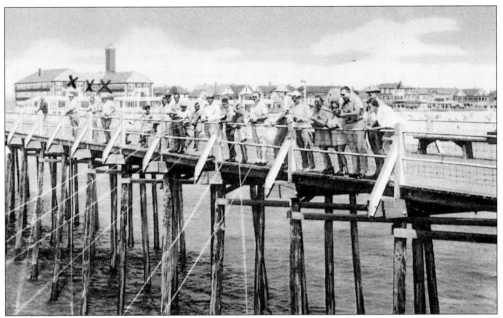

FISHING PIER. The fishing pier boasts avid anglers. In the background towers the Atlantic Hotel, next to the beginning row of cottages. The pier extended into the ocean, allowing for line fishing. Back then, fish were plenty, and an angler could snag a good-sized catch in no time. The pier burned in the 1925 fire and was rebuilt in 1929. Trapshooting also took place from the pier.

SINEPUXENT BAY. The pier calls to sailors wanting to sail calmer waters and to be able to see the opposite shore. Here, in Sinepuxent Bay (notice the spelling of "Synepuxent" on the card), gently rocking sailboats and canoes wait for owners to ride them out to the breathtaking horizon. This picture was taken c. 1929.

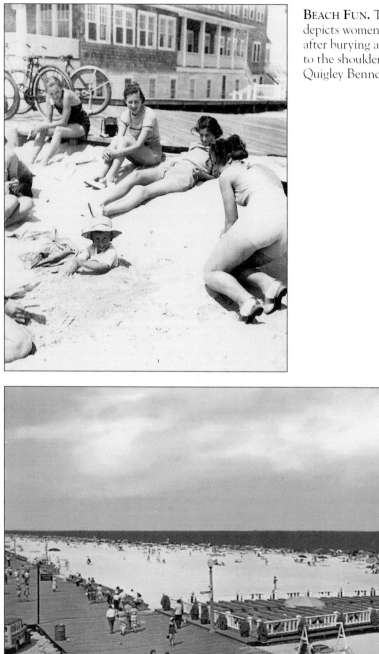

BEACH FUN. This July 1936 photo depicts women relaxing on the beach after burying a child in the sand up to the shoulders. (Courtesy of W. Quigley Bennett.)

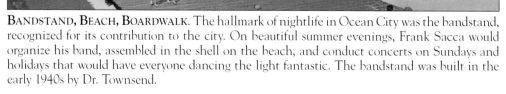

BANDSTAND, BEACH, BOARDWALK. The hallmark of nightlife in Ocean City was the bandstand, recognized for its contribution to the city. On beautiful summer evenings, Frank Sacca would organize his band, assembled in the shell on the beach, and conduct concerts on Sundays and holidays that would have everyone dancing the light fantastic. The bandstand was built in the early 1940s by Dr. Townsend.

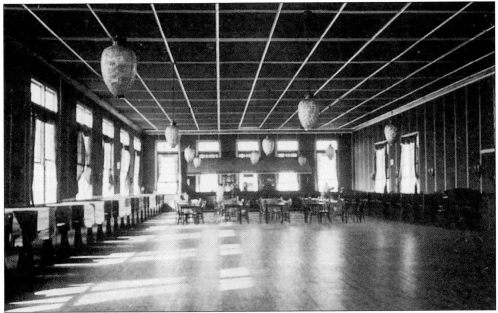

PIER BALLROOM. A local orchestra played here six nights a week unless a well-known band was scheduled for which tickets were sold in advance. John E. Jacob "shook a foot" here many times. This interior shot shows the ballroom during the summer of 1937.

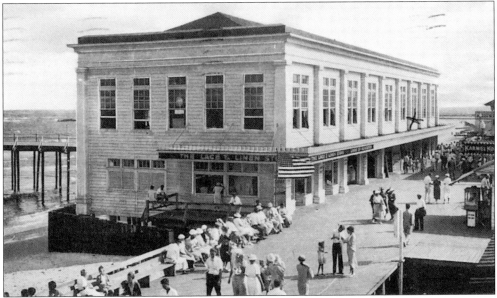

CONVENTION HALL AND PIER. Originally, the pier building substituted as a convention hall. Built by the state through the persistent efforts of William Preston Laws, the pier took three years to construct and was completed in 1907. Throughout the years, it was rebuilt, repaired, improved, and continually changed after being damaged by the 1925 fire and various storms. At the end of the pier, supported on pilings, was a large building that hung over the surf. The structure featured a "rounded roof with arched windows," and housed a dance pavilion, a theater, bowling, a billiards room, a restaurant, and a ballroom where big bands played for couples dressed in their finery.

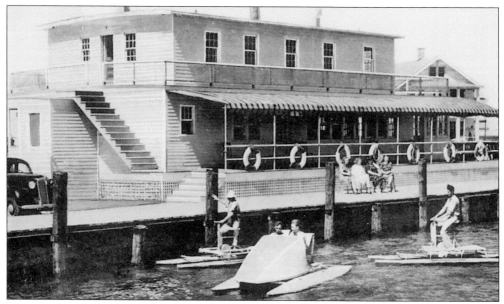

YACHT CLUB ISLAND CLUB HOUSE. This was Ocean City's first try at a private club; unfortunately, it succumbed to the Depression. In its hey-day, the club was for the well-to-do and idle rich who privately owned huge yachts. Boating was a way to pass the time and enjoy summer vacations at the beach. Ocean City's challenging Atlantic Ocean provided a venue for the brave risk-takers. The yacht club supplied not only boat docking facilities but a center for the elite to socialize and bond.

BILL'S CAFE AND AIRPORT. This site served as an airstrip, and though planes regularly landed on it, some did so precariously. John E. Jacob recalls at least one time when a landing plane ran off the runway and into the water. The airport had a 1,000-foot strip and a cross strip of 700 feet. This was Bill Ahtes Jr.'s baby; he was the aviator in the family. (Courtesy of William Ahtes Jr.)

Ten

DISASTERS

As a barrier island, Ocean City bears the brunt of coastal storms. In 1883, the *Sallie W. Kay* slammed the ground in a snowstorm before being swept away where she sank and seven crewmen were drowned. In 1916, another severe storm tore up Third Street, ripping apart property, including the Hamilton Hotel and the boardwalk. In 1917, a U.S. tanker hit a reef, killing 11 people. In 1918, heavy snow and ice collapsed the pier building. In 1922, the *Margaret Jones* took 22 men with her to the depths of the sea.

In 1925, freezing temperatures engulfed the hundred or so permanent Ocean City residents. At 7:30 a.m., the municipal power plant at the corner of Baltimore Avenue and Somerset Street was operational. Out of nowhere, sparks flew, and, within in no time, a fire raged. With only limited fire protection abilities and hydrants already frozen, the town knew there was little hope the flames could be stopped. The fire feasted on the Seaside Hotel, the Atlantic Hotel, Dolle's Candyland, the fishing pier, and the rebuilt pier building, as well as the Casino Theater, some amusements, the C.W. Purnell Cottage, and about two blocks of the boardwalk. In short, fire devoured nearly the entire town. Rebuilding was expensive and time consuming but accomplished all the same in 1926. Another fire, this time in 1927, burned the Congress Hall Hotel, and the next inferno destroyed the Pirates Club in the mid-1930s. Years later, fire consumed the Colonial Hotel, though this kind of damage was minor compared to what would come in 1933.

The August 1933 tempest proved catastrophic to property in Ocean City. After raining for nearly a week, the sixth day saw the torrents intensified. Throughout the day, the storm heightened, with wild winds shackling the already high tides in the bay area, surging currents to well over eight feet above normal crest. The howls from lashing gales were enough to spook any resident who had not evacuated, especially as the storm's thrust spiraled throughout the night. For three days, the potent winds and rain and the wild surf battered the shore. When the tumult finally died, it had cut a path of destruction that forever changed the geography, texture, and topography of the resort. Since the storm of 1933 had gouged a waterway fifty feet wide and eight feet deep, where land (now at the bottom of the ocean) had once been, there was no longer a physical connection to Assateague Island to the south, and growth could only go northward. Hence, the town fathers looked towards Delaware for development.

NEW INLET. The creation of the inlet was a result of the 1933 storm. (Courtesy of W. Quigley Bennett.)

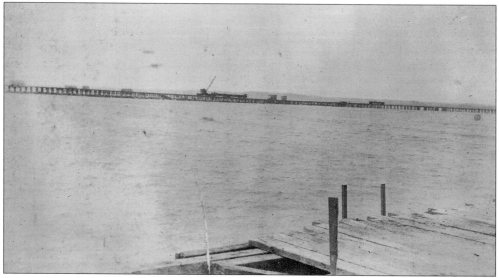

STORM AND BOARDWALK. After the 1933 storm, W. Quigley Bennett took this photo, showing some of the destruction of the boardwalk. Notice the missing planks. (Courtesy of W. Quigley Bennett.)

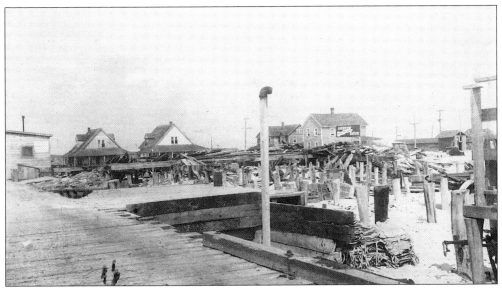

WHARF. Bennett captions this photo as "The result of the 1933 storm: Southern port down by the old ice house, now M.R. Ducks, on the wharf in the fishing village." (Courtesy of W. Quigley Bennett.)

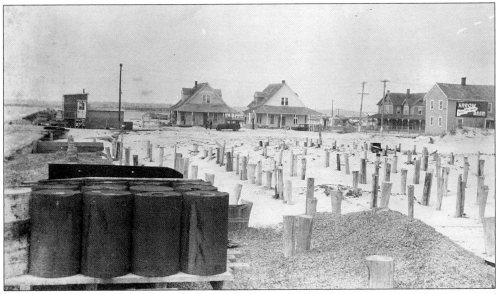

FISHING VILLAGE. "This is the Village sometime after the 1933 storm," commented Mr. Bennett. (Courtesy of W. Quigley Bennett.)

113

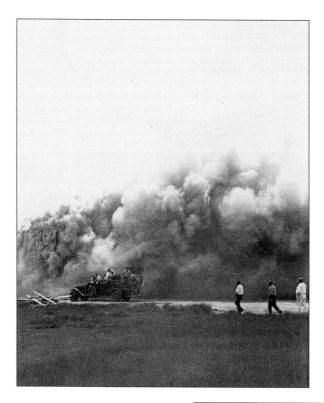

CLUB FIRE 1. This photo shows the destruction of the Pirates Club in mid-1930s by a persistent fire. (Courtesy of W. Quigley Bennett.)

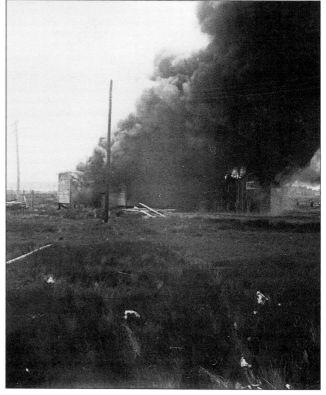

CLUB FIRE 2. In this second snapshot, we see the height, depth, and blackness of the smoke, which was so thick that no person could get near the flame source. (Courtesy of W. Quigley Bennett.)

Eleven

THE INLET: GOD'S GIFT TO OCEAN CITY

The August storm was bad. It brought rain of perhaps 10 inches a day for four days. Mountainous waves battered down the boardwalk. The railroad bridge was completely demolished, and the automobile bridge was so weakened that only one car was permitted to cross it at a time. Every tributary that entered into Sinepuxent Bay had dumped its rainwater into it. Water from the ocean, driven by the northern wind, had crashed away the low sand barrier. All that water with the incoming tide had raised the water level in the bay, and now it sought an outlet. The water broke through a low spot where the fishing camps were, just south of the boardwalk. The water swept through like a millrace, carrying loads of debris with it. And when the storm was over, the inlet had appeared. The problem now was to secure it. It took two years to get the project approved and the work done. In 1935, a concrete seawall had been built on the inlet's north side, and, the following February, funds were appropriated for two stone jetties on both sides of the inlet.

Four days after its birth, the first charter boat put to sea and millions have followed. Sport fishing has become a tremendous addition to the revenue of Ocean City. But commercial fishing, which was highly profitable at first, has become a problem. Lately, commercial fishermen contend that it is barely profitable because of state regulations and the cost of bait. The new salt level in the bay, however, killed the oyster crop and the famed Chincoteague oysters.

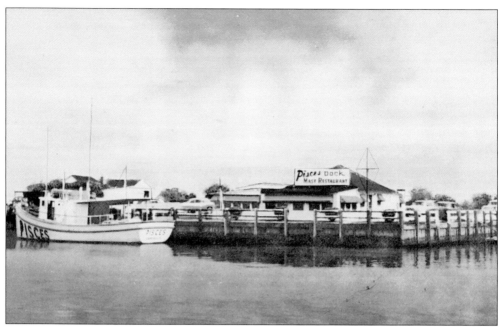

PISCES. The *Pisces* hasn't changed but the restaurant has. It is now the Mast Restaurant and there are more cars parked around it. (Courtesy of the late Fred Brueckmann.)

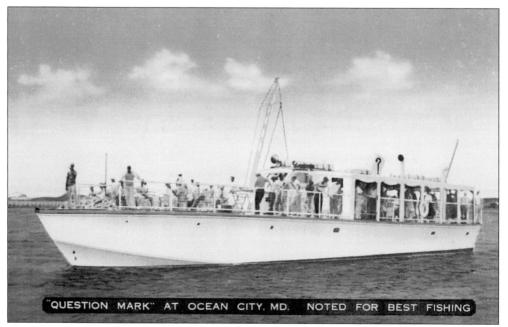

"QUESTION MARK" AT OCEAN CITY, MD. NOTED FOR BEST FISHING

QUESTION MARK. This is one of the two-trips-a-day fishing boat for tourists. She makes two trips a day, morning and afternoon, and sells sandwiches, soft drinks, and beer, but you have to haul in your own fish. (Courtesy of David Dypsky.)

THE COAST GUARD LOOKOUT TOWER. This card shows the Coast Guard lookout tower that is on the stone-and-concrete north jetty of the inlet. This card is postmarked 1941.

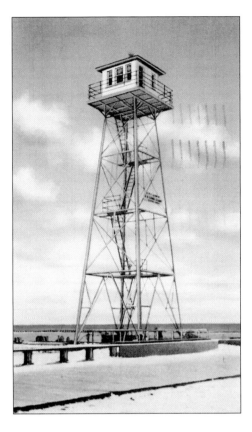

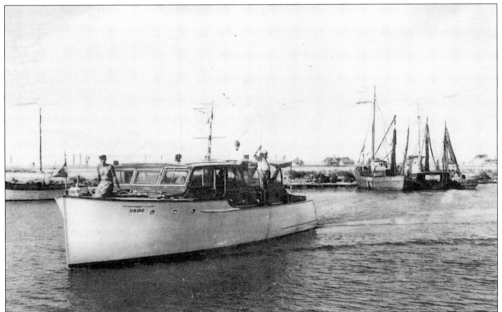

THE HARBOR. This is a scene from the harbor after the inlet cut itself through. It shows the commercial fishing boats with a charter ocean-going craft in the foreground, both business and pleasure. The postmark on this card is 1939.

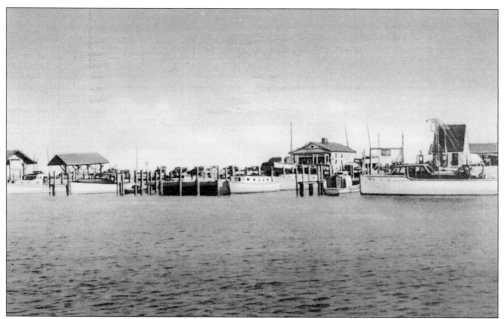

THE HARBOR. This card is postmarked 1947. The harbor has grown more congested, but the Harbor Club is still there.

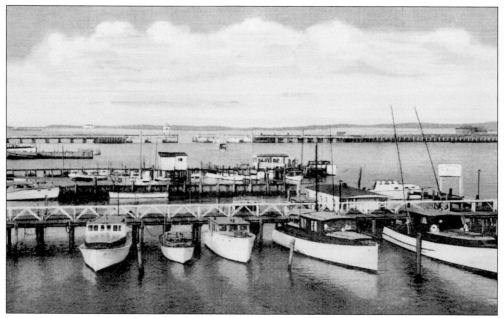

CHARTER FISHING BOAT DOCK ON SINEPUXENT BAY. Charter boat fishing is big business, and fishermen go out in the ocean 40 to 50 miles to hunt for the white marlin that gave rise to the claim that Ocean City is the White Marlin capital of the world. The annual contest brings fishermen from all over to Ocean City. This card was mailed c. 1949.

THE INLET AND ATLANTIC OCEAN. This more recent picture shows clearly the width of the inlet, the buildup of sand on the north side of it, the look of the jetty on the south side, and the retreating sand behind it. The government has undertaken a beach replenishment program to replace it.

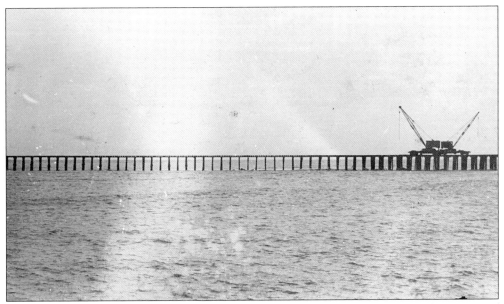

BUILDING A JETTY. This photo, taken in the 1930s, features the south jetty in the process of being built. (Courtesy of W. Quigley Bennett.)

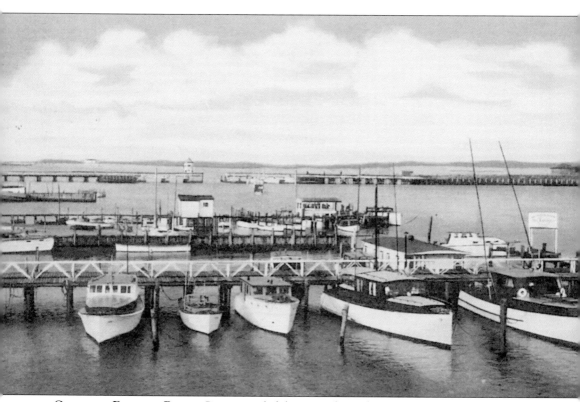

CHARTER FISHING BOAT. Commercial fishing is dying because of extremely strict state regulations. Commercial fishermen have been depending upon the horseshoe crab market, but since stricter regulations were placed upon other fish, state officials mandated a 25% cut in the crab market. The shellfish market also has declined, and clam licenses dropped from 106 in 1995 to 61 in 1998. Oyster licenses fell from 1,035 in 1995 to 882 in 1998. Only three oyster dredge boat licenses were issued in 1998. This image has a 1958 postmark.

Twelve

WEST OCEAN CITY

West Ocean City developed along old Route 50. When the new entrance to Ocean City was built, development began along the new road. The Alamo, the Sea Isle, and the Pines motels were built, as well as a fast food place and a golf driving range. When the inlet was created and a new harbor was developed on the west side of the bay, West Ocean City began to grow. The new seafood industry and charter boat fishing industry brought dollars flooding into West Ocean City, and with a new, four-lane bridge and open, undeveloped land leading to it, the area has boomed.

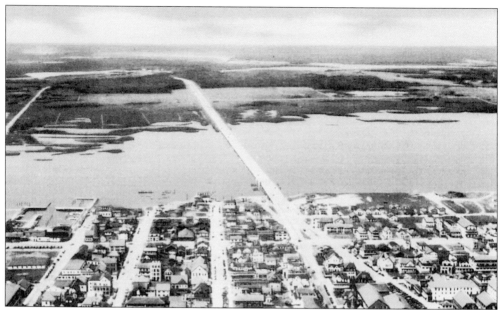

AIRPLANE VIEW SHOWING BRIDGE OVER SINEPUXENT. This picture shows both the new bridge and the approach to the old one. It also shows how empty both sides of the road were at the time. With good eyes one can follow the roadway up from old Route 50, now called Golf Course Road. Herring Creek is in the background.

THE VILLA NOVA. The Villa Nova Motel was established by Angelo M. Villani. The cottages were grouped in a U shape around a store, dance hall, and bar. There is posted on the wall of the bar an original 1939 poster advertising a dance to the music of the Blue Serenaders, admission 27¢ plus a 3¢ sales tax. The court has changed hands several times since then and the cottages and apartments have been sold as condominiums. (Courtesy of Tingle.)

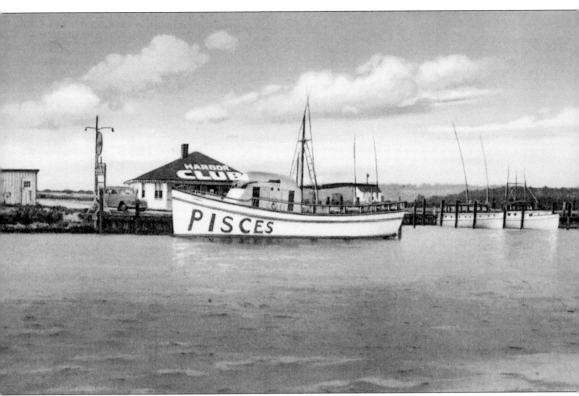

THE HARBOR CLUB. This club was run by two enterprising young ladies from Salisbury; they later sold it to Bob Ching, who operated it until he secured the LaGrand Hotel. It was while Bob Ching owned it that John E. Jacob saw, in a glass case there, the claw of a deep-water lobster that itself weighed three pounds. Before the inlet was created. no one caught lobster and some of them grew to be huge. The *Pisces* was among the first vessels to offer deep-sea fishing, making two trips daily and accommodating about 40 fishermen.

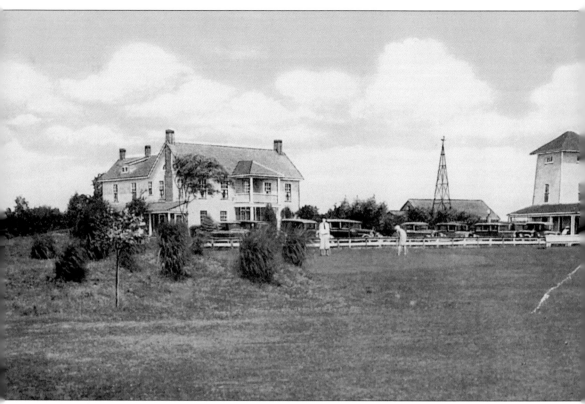

OLD OCEAN CITY GOLF CLUB. This was a nine-hole course that was located on the bay side of what is now called Golf Course Road, north of the present U.S. 50. The golf club has long since disappeared.

HERRING CREEK. One crosses a bridge over Herring Creek on the way into Ocean City. This view is of a restful and quiet residential area close to Ocean City.

Rambler Motel — Ocean City, Maryland

THE RAMBLER MOTEL. This was how the original motel looked. It was located on Elm Street, off old U.S. 50, and was built by Mr. and Mrs. Eugene L. Kidwell. (Courtesy of the late Fred Breuckmann.)

ALAMO COURT. This motel was owned and operated by Bill Weaver until his untimely death aboard his boat. It is now owned by Roscoe Nelson. Nelson is currently involved in the reconstruction of Alamo Court, which will return the structure to its former glory. He swears that after April 1, 1999, it will never close. The Alamo was built in 1945 and was the first motel built in the Ocean City area. This picture was taken c. 1973. (Courtesy of Aladdin.)

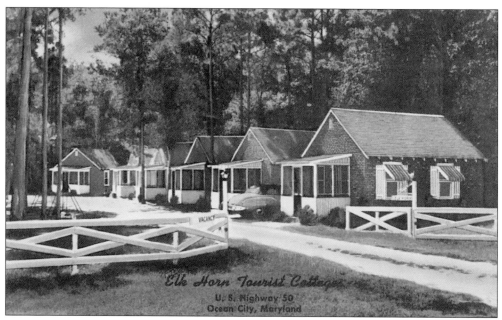

ELK HORN COTTAGES. These cottages were first built as inexpensive quarters for families with children. Some of them are still in use off Elm Street. They are now part of the Francis Scott Key complex. (Courtesy of the late Fred Brueckmann; courtesy of Tingle.)

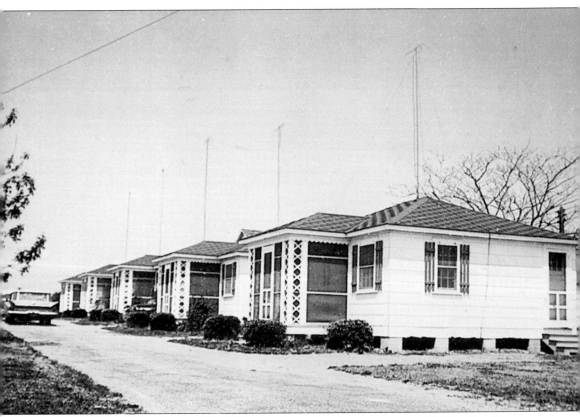

FISHER AND HARBOR COURT. Two-bedroom housekeeping cottages on Harbor Road were for upscale families. The cottages have recently been torn down and the land cleared for new construction. (Courtesy of the late Fred Brueckmann.)

BIBLIOGRAPHY

Corddry, Mary. *City on the Sand*. Centreville, MD: Tidewater Publishers, 1991.

Hurley, George M. and Suzanne B. Hurley. *Ocean City, A Pictorial History*. Virginia Beach: Donning Company/Publishers, 1979.

Matthews, Katie Gashin and William Russell Matthews. *Worcester County: A Pictorial History*.

Atlantic Flyer Aviation News. V 13. November 8, 1998.

Airport Apron Project. October 27, 1998.

City Meeting Minutes. Tuesday October 28, 1958–December 8, 1960.

Coastal Fisherman. "I've Worn Down my Own Path," Dale Timmons, Jr., p.27. May 11, 1995.

The Comprehensive Plan for Ocean City 1997. Mayor & City Council; Planning and Zoning Commission; Department of Planning & Community Development.

Dispatch Interview. p. 68. April 3, 1998.

Grant Agreement. US DOT, FAA. June 29, 1998.

Harrison, Sandra. *A History of Worcester County, Maryland*.

Mumford, Mary Ellen. *A History of Ocean City, Maryland*. Mayor & Council of Berlin, MD; Mayor & Council of Ocean City, MD; Calvin B. Taylor Banking Co, Berlin, MD. 16 pages.

Maryland Aviation Administration. "Airport Data Sheet." October 27, 1998.

Kanamine, Linda. "No Boardless Walk for Ocean City." *Government*. October 26, 1985.

Ferguson, Anita. "Ocean City Mulls Parking Lot." *Maryland Times Press*.

Ocean City Revisited 1998. Lipman, Frizzell & Mitchell LLC; Baltimore, MD.

Visitor Guides. 1998, 1999. *Year 2000, Sea for Yourself*. Town of Ocean City MD; Dept of Tourism; Ocean City Convention & Visitors Bureau; Ocean City PR Division.

Sportfishing. Ocean City Marlin Club, 1998.

Sunny Day Guides. Ocean City, Maryland

Town of Ocean City: Ocean City, Maryland: A Report for All Seasons. September 28, 1998.

Brigham, Kenna and Carol Hussey. *Ocean City, Maryland Churches*; November 1998; and *Ocean City, Maryland's Boardwalk Through the Years*. December 1998

Finkbeiner, Robert, and Jeff Disharoon. *The Annexation of Ocean City*. October 1998.